VICTORIAN LONDON
THROUGH TIME
Colin Manton

AMBERLEY

*In memory of Professor Colin Platt and Doctor Robert ('Bob') Bushaway,
late of the History Department, the University of Southampton, whose
encouragement and friendship will always be treasured.*

First published 2017

Amberley Publishing
The Hill, Stroud, Gloucestershire, GL5 4EP
www.amberley-books.com

Copyright © Colin Manton, 2017

The right of Colin Manton to be identified as the Author
of this work has been asserted in accordance with the
Copyrights, Designs and Patents Act 1988.

ISBN 978 1 4456 6252 7 (print)
ISBN 978 1 4456 6253 4 (ebook)

British Library Cataloguing in Publication Data.
A catalogue record for this book is available from the
British Library.

Origination by Amberley Publishing.
Printed in Great Britain.

Contents

Introduction

'London is the greatest city in the world.'

Sadiq Khan, Mayor of London

2016

The inspiration for this book is a fascinating, enthralling, monumental Victorian work, *Old and New London: a Narrative of Its History, Its People, and Its Places*, published by Cassell, Petter and Galpin of London, Paris and New York in six large volumes from 1872 onwards. These comprehensive volumes had two authors: volumes I and II, George Walter Thornbury (1828–76), an adaptable writer and sometime collaborator with Charles Dickens; and volumes III, IV, V and VI, Edward Walford (1823–1897), principally a genealogical historian and contributor to *The Times*. This vast work is certainly scholarly, not to say antiquarian and even idiosyncratic but nevertheless a valuable historical window on Victorian London.

The authors were contemporaries of, for example, Charles Dickens, whose novels reflected Victorian poverty, inequality and the slow machinations of the law; Gustave Doré, who, being French, brought a 'foreigner's' eye to bear on the capital's almost frightening growth, teeming populace and the great contrasts in wealth to be seen; and, of course, Henry Mayhew, perhaps the first 'social investigator' with his exhaustive, pioneering interviews with London 'street folk'. Although not similarly setting out to campaign or to change, *Old and New London* has something of all these critical attributes and much more – a wealth of historical and literary anecdotes and even accounts of London's old customs and legends that might otherwise have been lost.

Probably the most inspiring feature, though, of *Old and New London* is the illustrations, which contain magnificent plates of the key landmarks – St Paul's Cathedral and Westminster Abbey, for example – but the volumes go beneath the surface too, depicting a much older world that, although 'Victorian' in a sense, was about to disappear forever, a victim of inevitable progress – the old coffee houses, such as Garraways, where modern financial services ('the City') had their birth. Perhaps most fascinating of all, those ordinary scenes, familiar to the Victorians – often captioned 'From a sketch taken at the time' or '...shortly before demolition' – are snapshots of a vanished London taken at a time when advancing technology did not quite allow photographs to be printed and published in such books. Views of Middle Row, Holborn and 'The Old Fish Shop' have tremendous immediacy, as have the engravings of horribly overcrowded tenements or 'rookeries'.

Old and New London naturally concentrates on the City and Westminster but also ventures much further afield into the Victorian suburbs, west, north and south. The exploration of the east, though, is somewhat limited. Apart from St Katharine's, London's docks, stretching ever eastwards along the Thames, are barely explored. The authors shared this limitation in common with other Victorian writers but, from a geographical point of view, 'docklands' was almost another 'London' and not easily accessible, apart from the communities who lived and worked there. It was a question of security too. Nevertheless, *Old and New London* had the vision to recognise that London was the greatest port in the world and the chief source of the capital's immense wealth-creating ability.

The docks, combined with London's role as a complex market – its sheer size and wealth and the huge numbers of people and consumers – historically forged London into Britain's greatest single concentration of manufacturing industry. The brewing industry is a good example. (Hall, 1962.)

Naturally, *Old and New London* reveals some bias and also the authors' prejudices and interests – perhaps an undue concentration on the rich and famous at one extreme and London's many prisons at the other. Nor does *Old and New London* really investigate some of the more positive social developments of the time: new blocks of more affordable housing (at least for the 'artisan' class);

new schools (the Board Schools), which meant universal primary education, however basic; and, if harshly, the grim new workhouse system under the strict Poor Law Amendment Act of 1834. This at least provided some refuge off the streets for the destitute, if condemned by Charles Dickens in *Oliver Twist* when Oliver unthinkably asks for 'More...'

One of the strengths of the two authors was to recognise 'the shock of the new', the huge social impact created by the great Victorian metropolitan improvements, Holborn Viaduct, for example, and the massive embankments along the Thames – one of the city's most extraordinary creations. Less visibly, 'underground London', not just the new railway system but, even more vitally for London's future, Sir Joseph Bazalgette's great system of intercepting sewers, which saved London from fatal, waterborne epidemics, is graphically interpreted.

Bazalgette's great scheme was only made possible by the Victorians' significant departure from the old laissez-faire attitude, the creation of the London's first over-arching municipal authority, the Metropolitan Board of Works (MBW), set up in 1855 (and replaced by the London County Council, or LCC, in 1889). Whatever the Board's imperfections, it got vital things done, unlike the squabbling parishes of which London was composed or the efficient but then rather stand-offish Corporation of London.

What emerges from the pages of *Old and New London* is a very different London from that of its Georgian predecessor: the population had doubled from nearly a million to almost 2 million (or 959,310 in 1801 to 1,949,277 in 1841). The increase even gained momentum, a measure of London's success and world dominance, reaching 4,536,267 in 1901, the year of Queen Victoria's death and the end of an extraordinary era. ('Inner London' figures' from *The London Encyclopaedia*, 1983.) While most of this growth was accounted for by immigration from the rural hinterland, the roots of today's multicultural London were becoming established: the Irish community at Seven Dials, for example, and the Jewish community around Petticoat Lane.

The coming of the railways was perhaps the most obvious structural change in Victorian London. The world's first great termini were deliberately excluded from the centre and their façades lined the Euston Road, starting with Euston, to the north of the city. Later, termini were allowed to penetrate the centre from the south – Cannon Street, for example – reaching their final destinations across massive new bridges, spanning the Thames. Central and, indeed, outer areas were made accessible by rail, however, by daringly constructing the new railways running under the streets, linking the termini in a huge 'circle' – the world's first 'Underground'. These rapid communications meant that Victorian London truly became a national capital and the new Palace of Westminster symbolised this.

In a more abstract but nevertheless highly visible sense, London became a unique cultural centre with the building of impressive national museums, open to all: the neoclassical British Museum, Bloomsbury, for example, and its offshoot, the Gothic Natural History Museum, South Kensington. Another way of characterising the era, incidentally, would be 'the age of the dinosaur', when the old tenets of religion and conservatism were scientifically challenged.

Many of the great Victorian buildings survived, of course, to become today's icons. What is so different about the present time, however, are the high-rise buildings dominating the skyline, like the Shard. At a personal level, the sight of joggers and the universality of smartphones is so historically new. Significantly, though, motor transport has crucially affected modern London. Ironically, despite their technological ingenuity, the Victorians remained totally dependent on the horse for road transport, as *Old and New London* illustrates. Today, London's roads are even more heavily congested (and polluted) by buses, taxis, cars and trucks. And, far above, the audible reminder that although London today is still a seaport to the east, the city now has one of the world's busiest airports to the west. This was certainly not on the Victorian agenda.

The City

Quoting from *Old and New London*, published in 1878, the aim of this book is to illustrate 'London as it was and is it is', comparing the appearance of the capital in the Victorian era with today's scene and looking at the history of the city. However, in the words of *Old and New London* again, 'Writing the history of a vast city like London is like writing a history of the ocean – the area is so vast, its inhabitants so multifarious, the treasures that lie in its depths so countless. What aspect of the great chameleon city should one select?'

For practical reasons, the more central and accessible areas of London are concentrated upon here: the City, its financial institutions and its environs; and Westminster, the Embankment, Parliament and the districts immediately to the west and to the north, including the great museums and the railway termini. Finally, areas south of the River Thames are explored, including the last days of Vauxhall Pleasure Gardens.

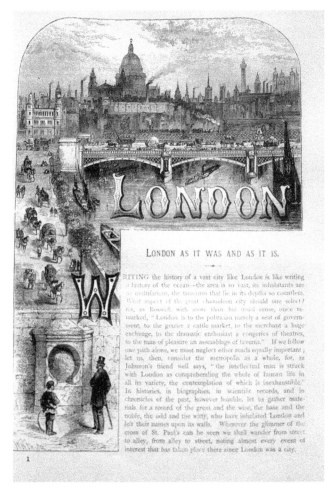

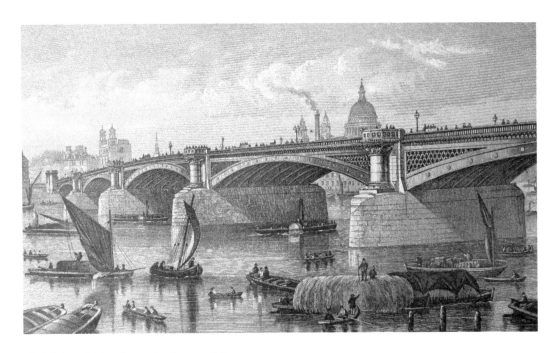

Blackfriars Bridge from the Surrey Side

Blackfriars Bridge links the City with the Borough of Southwark. The present bridge, built by the City Corporation and designed by Joseph Cubitt and H. Carr, opened in 1869, replacing an older structure completed a century earlier – the third bridge to span the Thames in London. The Quarterly Review of April 1872 conceded that the new bridge pleased the public but criticised the design as '...a wonder of depravity. Polished granite columns of amazing thickness, with carved capitals of stupendous weight, all made to give shop-room for an apple-woman or a convenient suicide'. (*Old and New London*, Vol. I) Queen Victoria opened the bridge on the same day as the Holborn Viaduct. The dome of St Paul's Cathedral is clearly visible in both views, but the barges that brought in hay to feed Victorian London's many working horses have long since disappeared.

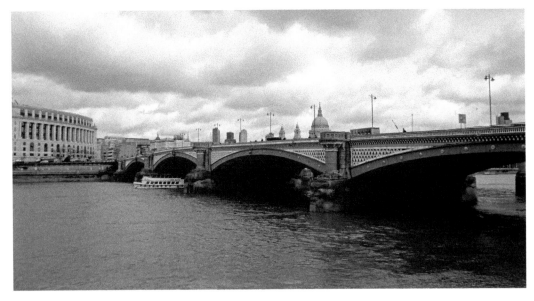

St Paul's from Ludgate Circus

Ludgate Circus is a short walk from the north end of Blackfriars Bridge when '... we come full-butt upon the great grey dome. The finest building in London with the worst approach; the shrine of heroes; the model of grace; the *chef d'oeuvre* of a great genius, rises before us...' (*Old and New London,* Vol. I). The tomb of the 'great genius' Sir Christopher Wren, architect of the present cathedral (completed in 1711), lies within the cathedral, as do the tombs of Lord Nelson and of the Duke of Wellington. The bravery of a team of volunteers, the St Paul's Watch, saved the cathedral from incendiary bombs dropped in the Second World War. The Victorian artist deliberately exaggerated the cathedral's dome to convey grandeur. The nineteenth-century railway viaduct, which sadly obscured the view, carried the London, Chatham & Dover Railway. It was demolished during the works for the new Thameslink line, which opened in 1990.

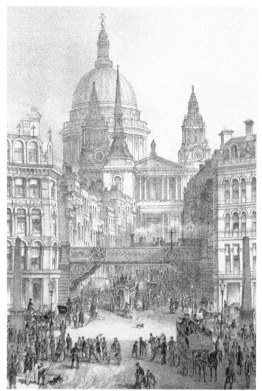

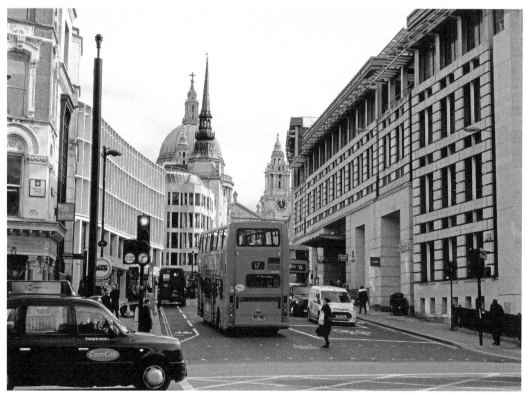

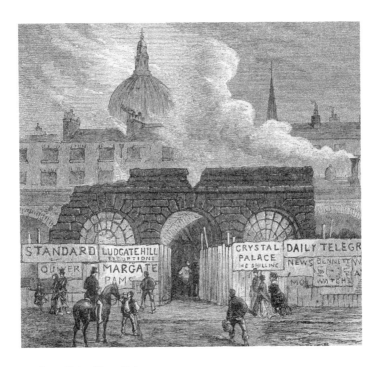

The Last Remains of the Fleet Prison

Today, it appears inconceivable that one of London's most notorious prisons stood here, on the north side of Farringdon Street. 'It is difficult to carry the mind back and imagine this old London prison, carted away in 1846, a building of nearly seven centuries' existence; yet so it was.' Dickens's creation, Mr Pickwick, was detained there and observed the demeanour of the prisoners '...a listless, jail-bird, careless swagger, a vagabondish, who's-afraid sort of bearing- which is wholly indescribable in words.' (*Old and New London,* Vol. II). The contrast between the fragment of ancient prison wall and the Victorian locomotive, steaming towards Ludgate Hill, with St Paul's dome in the distance, is quite extraordinary. The poster offers excursions to the Crystal Palace, relocated to Sydenham, South London, for a shilling. The railway company's massive, cast-iron coat of arms, restored and painted, survives at the south-west end of the present Blackfriars station.

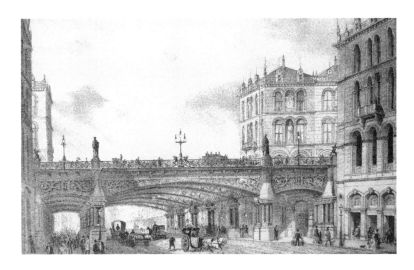

The Holborn Viaduct

The Holborn Viaduct, spanning the old valley of the Fleet, dominates the north end of Farringdon Street, '...one of the greatest and most successful works ever undertaken in the city of London – the Holborn Valley Improvements, an undertaking which will ever be quoted as a notable example of the energy and public spirit of our time'. Designed by William Heywood, the City surveyor, and described by the *Builder* as 'so grand and yet so simple', the viaduct took six years of construction and involved considerable demolition of old streets and buildings. (*Old and New London,* Vol. II). The project succeeded in maintaining vital connections with the lateral thoroughfares and in containing the essential services: sewers, gas and water pipes, and telegraph lines and ventilating shafts. The ornate parapet statues represent Commerce and Agriculture on the south and Science and Fine Art on the north side. This grand achievement was fittingly opened by Queen Victoria on same day as nearby Blackfriars Bridge on 6 November 1869.

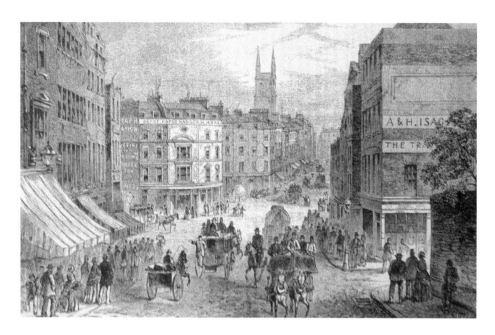

Holborn Valley and Snow Hill prior to the Construction of the Viaduct.

The view eastwards from the viaduct reveals the impressive carriageway, 80 feet wide and 1,400 feet long. Modern development has shrouded the tower of the medieval church of St Sepulchre, visible in the Victorian view. The new viaduct importantly eliminated the 'inconvenience and disagreeableness of the approach to the City from the west by Holborn'. Before that, coaches, carriages, wagons and horses risked serious accident owing to the 'dangerous descent of Holborn Hill'. (*Old and New London,* Vol. II). This brilliant scheme brought an immediate downside, however. Many of the local poor were made homeless by the wholesale clearance of their crowded dwellings necessitated by the vast projects. This was unfortunately a recurring theme in Victorian London. To the authorities, the construction of great works also offered a harsh solution to 'the problem of the poor', the large scale demolition of overcrowded tenements.

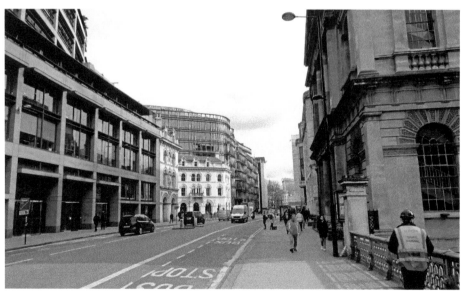

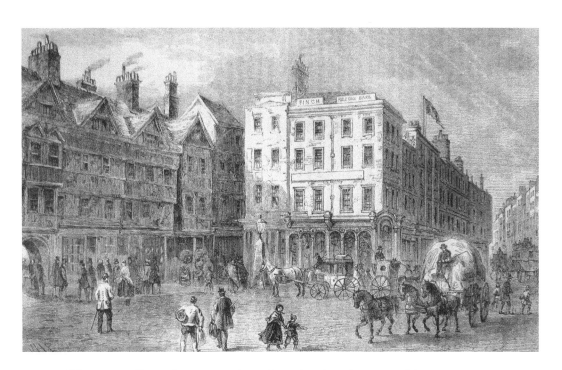

Middle Row, Holborn, from a Drawing Taken Shortly Before Demolition

Middle Row, Holborn, an ancient block of houses at the City's western boundary, which stood at the south end of Gray's Inn Road, was tolerated long after it had become generally condemned as a most inconvenient obstruction to traffic. The bottleneck was finally removed in 1868. Holborn itself remained of ancient importance as one of the locations of the Inns of Court. Although Middle Row disappeared, the views show other medieval buildings on the left, a relatively rare survival in London and, in this case, the historic Staple Inn. Macabrely, this was the old route along which convicted criminals were carted from the Tower and from Newgate Gaol to execution at Tyburn Gallows.

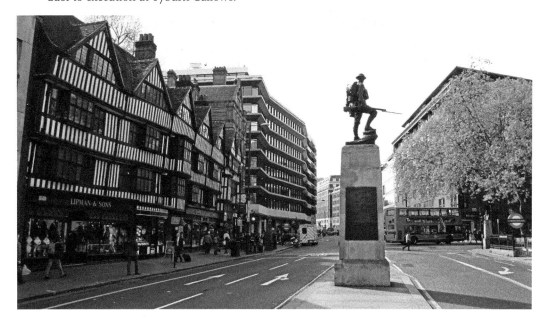

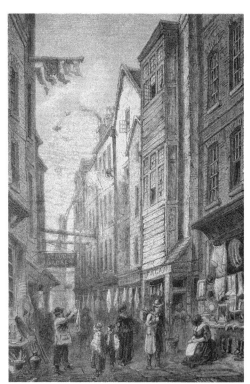

Field Lane *c.* 1840

Swept away by the construction of the viaduct and the Farringdon Road, the once notorious Field Lane was one of the Victorian capital's most overcrowded and insanitary tenements. The *Builder* of 24 April 1869 mentioned 'the frequent discovery of all sorts of concealed passages for escape, and nooks for hiding plunder in the villainous old houses of Field Lane and its unsavoury neighbourhood, the removal of which alone should cause the Holborn Valley Improvement to be considered a blessing to this part of London'. (*Old and New London,* Vol. II). Henry Mayhew, however, considered that, 'These watercress sellers are members of a class so poverty-stricken that their extreme want alone would almost justify them in taking to thieving, yet they can be trusted to pay the few pence they owe...' The lane has vanished but it is probably marked today by the passageway at the junction of Saffron Hill and Charterhouse Street. The new buildings of Anglia Ruskin University now occupy the site.

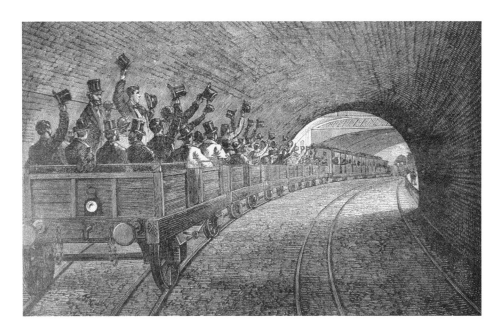

Trial Trip on the Underground Railway, 1863

A truly momentous Victorian development – the world's first underground railway – is symbolised by today's busy Farringdon station. This was a stop on the former Metropolitan Railway, which opened in 1863. This unprecedented railway engineering advance propelled London into the modern era of urban mass transport and expansion far more effectively than the earlier Victorian transport developments, horse-drawn coaches and trams. Running 4 miles from Paddington to Farringdon, the steam-powered 'Underground' opened up the capital to business and pleasure. Such was its success that the new service was rapidly adopted by all classes. The 'cut and cover' engineering technique kept the inevitable disruption just about manageable. The early lines were excavated along the centre of streets and then simply covered over to form the tunnel. Improved public transport benefitted the more fortunate of the working classes who could afford to migrate outwards to new housing in the new Victorian suburbs.

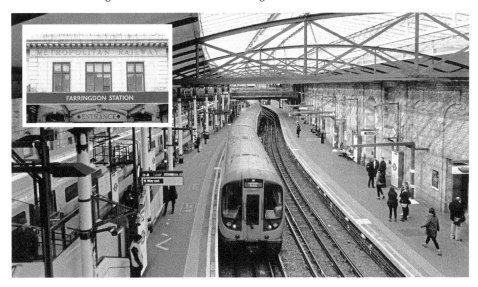

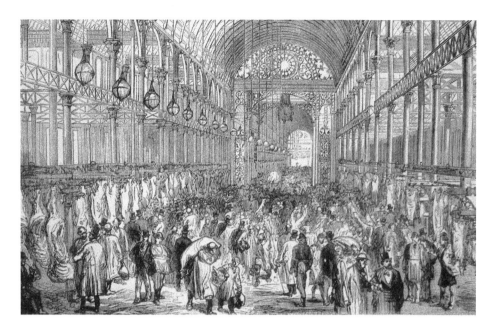

The Metropolitan Meat Market

The City established a cattle market at Smithfield in 1638 but by the Victorian era, as buildings surrounded the market, everything got out of hand. In 1855 the sale of live cattle and horses was finally moved north to the Metropolitan Cattle Market in Islington. Thenceforth, Smithfield became a meat market only. A highly practical meat trading solution was designed by the City architect, Horace Jones, inspired by Joseph Paxton's earlier Crystal Palace of 1851. Smithfield opened in 1868 as the London Central Meat Market. The project required the excavation of 172,000 tons of earth and 'Twenty-one main girders, of Titanic strength...' (*Old and New London,* Vol. II). Again, Victorian ingenuity was evident: the capacious, well ventilated iron and glass structure kept temperatures relatively cool in the pre-refrigeration era and the market was served by underground railways linking it to the main stations. In recent years, Smithfield has been extensively modernised and upgraded to meet EU regulations.

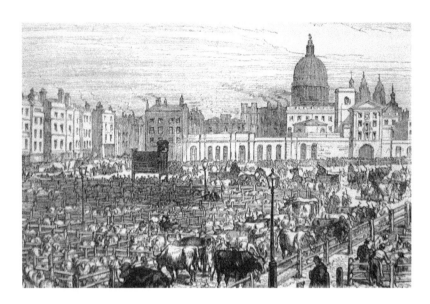

Old Smithfield Market

Smithfield originally meant 'smoothfield' and was historically the area for unpleasant or dangerous activities unsuited to the City – not only the cattle market but jousting tournaments, duelling and the burning of heretics and witches. The traditional and often riotous Bartholomew Fair was suppressed 1855 for being too licentious for the Victorian authorities' moral sensitivities. It is difficult to imagine today but Wat Tyler, the leader of the Peasants' Revolt, parleyed here with Richard II in 1381. The Lord Mayor, Sir William Walworth, brought the matter to an abrupt conclusion when he stabbed Tyler, who was subsequently executed in front of St Bartholomew's Hospital. This great medieval institution survives in the distance, although the dome of St Paul's is not visible in the present view. The densely packed cattle pens were described by Dickens in *Oliver Twist*, 'ankle deep in filth and mire'. Beasts sometimes escaped and perhaps the saying 'bull in a china shop' originated here. The Victorian railway serving the market was underneath the open area, now a car park.

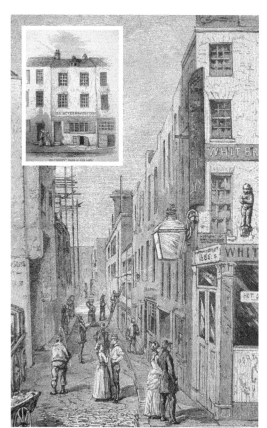

Cock Lane

Close to Smithfield lies Cock Lane. Within the radius of a few strides, London presents one of the many extraordinary contrasts in time and space that characterise the city. The figure of a gilt cherub (rudely called 'the fat boy') is said to mark the full extent of the Great Fire of London, which destroyed old St Paul's, many churches, and thousands of dwellings. As the old engraving shows, the 'boy' was formerly affixed to the notorious 'Fortune of War' public house. In 1762 a ghostly phenomenon was said to have manifested itself at No. 33 Cock Lane. Elizabeth, the twelve-year-old daughter of William Parsons, officiating clerk of the nearby church of St Sepulchre, reputedly heard ghostly knocking and scratching at night. This mysterious case attracted curious crowds and rapidly became a *cause celebre*. The folklorist Steve Roud argues that the event was clearly a fraud, although some modern writers claim that it has 'never been explained.' Although the lane is recognisable today, the old atmosphere has dissipated under the pace of modern development. (Roud, 2008).

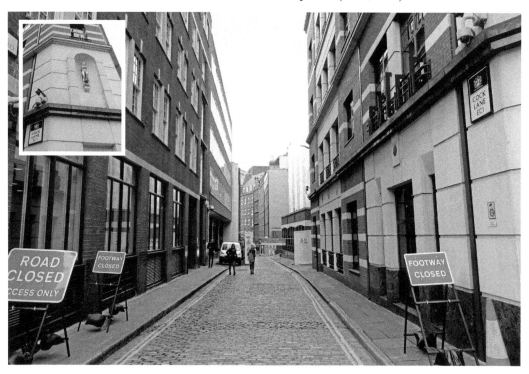

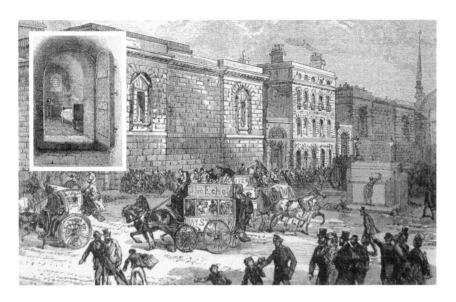

Front of Newgate from the Old Bailey

The lofty edifice of the Central Criminal Court, opened in 1907, traditionally known by the name of the local thoroughfare, the Old Bailey, stands immediately to the south-east of the viaduct. ('When will you pay me, say the bells of Old Bailey,' as the old rhyme goes.) This was the site of the forbidding Newgate Gaol and the dreaded condemned cell, a fearsome reminder in Victorian London of the dire penalties of criminal deeds. Executions were transferred here from Tyburn in 1793 and, inconceivably by today's standards, crowded public hangings were conducted outside the old gaol until the practice was abolished in 1868 and moved inside the walls. There was a much older gaol building, rebuilt and completed to George Dance's severe design in 1778 but then torched by the incensed, violent Gordon Rioters 1780, although immediately rebuilt. This monument to suffering and violent events was not finally demolished until 1902, to make way for the new court. The old bell that used to be sounded at executions is displayed in the church of St Sepulchre just opposite and a Newgate cell door is exhibited in the Museum of London nearby.

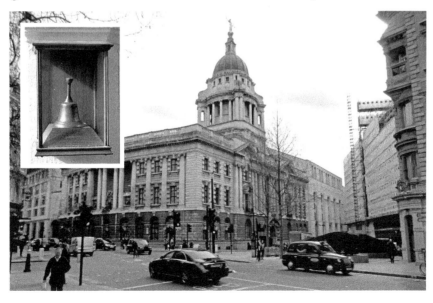

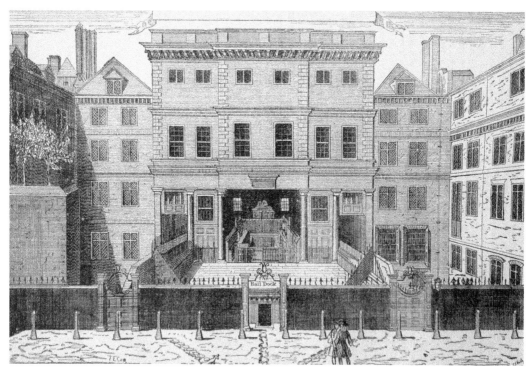

The Old Sessions House in the Old Bailey in 1750

The first Old Bailey Sessions House was built beside Newgate Gaol in 1539. The courtroom of this earlier building, as the old view shows, was deliberately left open to reduce the risk of prisoners infecting the judges, court officials, lawyers, witnesses and visitors with gaol fever, a particularly virulent form of typhus. The present Central Criminal Court on the site is famous for the bronze statue, *Justice*, surmounting the dome, over 200 feet above the ground. Less well known is the carved inscription facing the Old Bailey today: 'DEFEND THE CHILDREN OF THE POOR AND PUNISH THE WRONGDOER'. Newgate's frightening reputation stamped itself on the City and, in a sense, remains, evidenced by a section of the old stone wall that survives behind the present court building, although not publicly accessible.

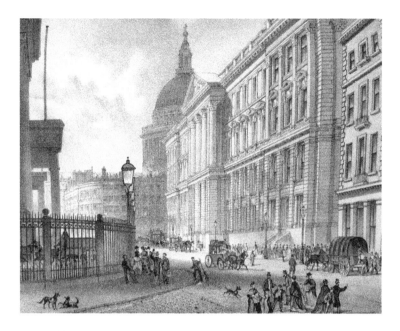

The New Post Office (St Martin's Le Grande)

The accelerating growth in postal services through the eighteenth century made a much larger building necessary to replace the very basic premises of the previous era. The ecclesiastical buildings of St Martin's Le Grand were cleared and a magnificent, purpose-built post office was erected in 1829. The architect was Sir Robert Smirke, who also designed the British Museum. The new premises were a great advance in managing the post. The functions of the post office, sorting office and administration were organised under the same roof. An indicator of the building's advanced facilities was the installation of gas lighting, provided by over a thousand burners. It would have been an exciting sight to see the horse-drawn mail coaches setting out from here. A replica of a 'Penfold' pillar box stands today on the pavement but the old building was demolished in 1912 and replaced by a new postal headquarters in nearby King Edward Street, although this is no longer in use as a post office.

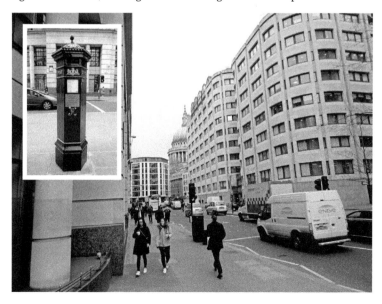

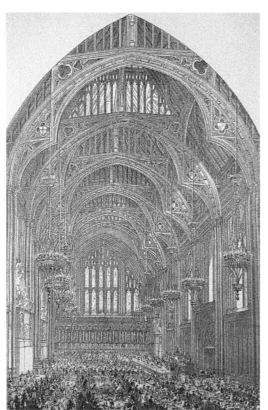

A Banquet at the Guildhall

Slightly to the east, just off Gresham Steet, stands the City's focal point, the historic medieval Guildhall. This magnificent structure is not only the City's centre of civic government where lord mayors and sheriffs have been elected and meetings of the Court of Common Council were held since time immemorial. The structure itself probably dates from 1128, although it has been considerably restored and modified over the centuries. Impressively, Guildhall is the largest hall in England after Westminster Hall and possesses the most extensive medieval crypt in London. The Guildhall survived the Great Fire of 1666 and, centuries later, wartime bombing. The roof was set on fire during an air raid in 1940. A temporary roof served until 1953 when Sir Giles Gilbert Scott's proposal for a new roof with stone arches strengthened by steel trusses was accepted. The Guildhall is also famous for the statues of two legendary giants, Gog and Magog, said to be the founders 'in 1,000 BC of Albion's capital city, New Troy' or London, as it became known.

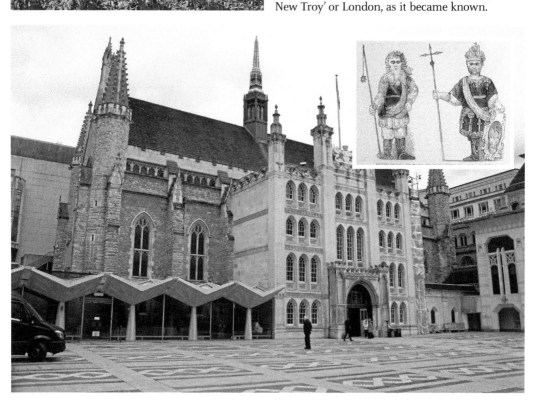

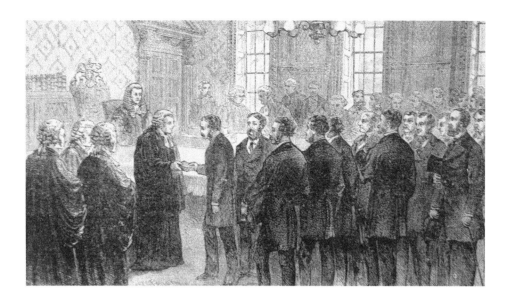

Trial of the Pix

On the corner of Foster Lane stands the Livery Hall of the Goldsmiths' Company. A hall was recorded in 1366 but the company's present accommodation, in Renaissance style and completed by Phillip Hardwick in 1829–35, is a monument to the company's high standing in order of precedence. The Livery Companies have their complex origins in London's early twelfth-century craft guilds. They may be popularly regarded as meeting mainly to consume huge banquets but, charitably and educationally, they do much for the public good. The Goldsmiths' Company received its first charter in 1327 and became one of the most wealthy and powerful of the 'Great Companies'. It had the responsibility for ensuring the quality of gold and silver objects, which had to be 'marked' (which incorporated an identifying leopard's head) in the Goldsmiths' Hall before sale, from which comes the term 'hallmarking'. From 1248, the company had a specific responsibility for ensuring that the coin of the realm meets the standard. The ceremony is still performed annually in the Trial of the Pyx (or pix) using the old terminology.

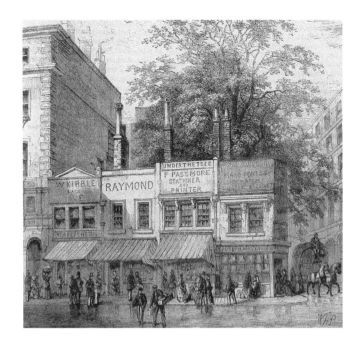

The Tree at the Corner of Wood Street

In contrast to the grandeur of the Guildhall and of Goldsmith's Hall is this remarkable survival at the corner of Wood Street: a tree. Wood Street runs from London Wall to Cheapside, formerly London's premier shopping area before the City became the chief business centre when Charles Dickens was a young man and fashion migrated west. There is some conjecture about the street's name, which could be a reference to its houses' being built of wood and not of stone, contrary to King Richard I's edict, to reduce risk of fire. The author of *Old and New London* pauses here to admire 'That pleasant tree at the left-hand corner of Wood Street, which has cheered many a weary business man with memories of the fresh green field far away...' This tree was 'for long the residence of rooks ... In 1845 two fresh nests were built, and one is still visible...' (*Old and New London,* Vol. I). The little shop survives even today and, within recent memory, traded as a traditional 'actual shirt maker'.

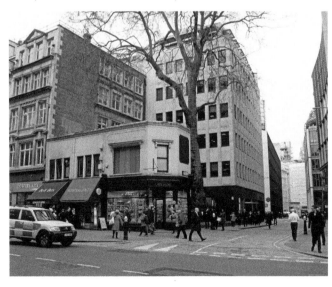

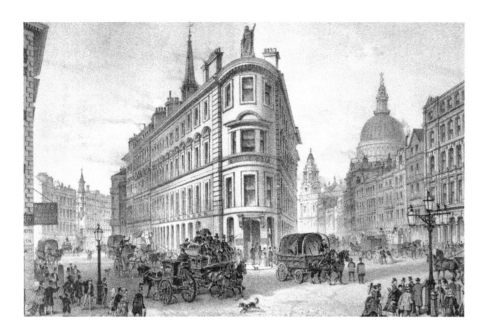

Queen Victoria Street

Queen Victoria Street is another prime example of the massive transformation of the Victorian centre. Cut through the old buildings of the City during the years 1867–71 from the Bank of England to the Embankment and Blackfriars Bridge across the Thames (the opening view in this book's sequence of illustrations), this huge construction not only sped up communication but also destroyed the traditional City and its old, low-rise dwellings, shops and small businesses that Charles Dickens knew so well – Scrooge and his counting house perhaps comes to mind. And, under all this, such was Victorian ambition and energy, the District Line was excavated underground simultaneously to transport clerks to the City. Even the revolutionary Victorian office and warehousing redevelopments have been overtaken by recent events and have disappeared to be replaced by buildings more suited to late twentieth- and twenty-first-century requirements.

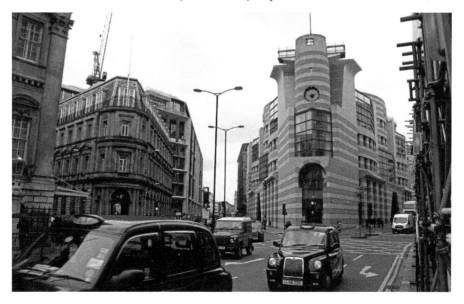

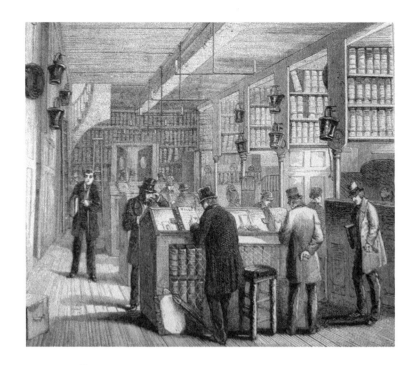

The Prerogative Office, Doctors' Commons

Unimaginably now, the area between Queen Victoria Street and St Paul's was once occupied by the labyrinthine district of small legal offices known as Doctors' Commons. Well known to Charles Dickens, it was here that the slow, unfathomable machinations of the archaic ecclesiastical law were administered. Jingle, for example, obtains a marriage licence from Doctors' Commons in *The Pickwick Papers*. A licence from the Commons was a not unusual expediency in a Victorian London of hastily arranged alliances (Lee, 2012). Very recently, the area has been completely redeveloped again to meet the needs of the IT era. The chain owning a startlingly new pub, sited in what was once the Commons, 'The Green Man' (perhaps deliberately?) chose a traditional name that embodies ancient Pagan beliefs from a distant time when nature rather than computers ruled the Thames and its banks.

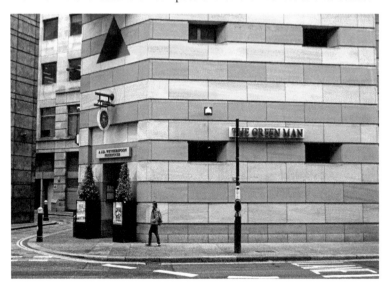

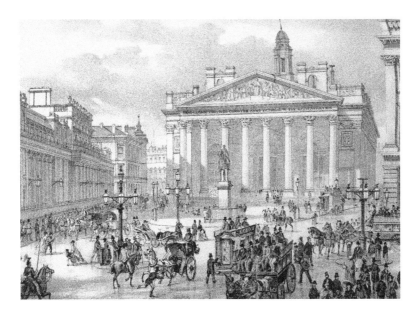

Royal Exchange and Bank of England from Mansion House

These buildings form another of those iconic London backdrops so favoured by the media when financial crises loom. The Bank was founded under an Act of 1694 to enable the government to raise funds to fight the French-Dutch War. It moved to a Threadneedle Street address in 1734. The Bank was attacked by the Gordon rioters in 1780 and, as a consequence, a military guard was maintained until 1973. It gained its nickname in 1797 when Sheridan, the playwright, spoke in the House of Commons of 'an elderly lady in the city of great credit and long standing'. The bank's present impressive neoclassical appearance is largely the creation of Sir John Soane's reconstruction started in 1788, although the interior was much altered by Sir Herbert Baker in the 1920s and 1930s. The adjacent Royal Exchange was inspired by Antwerp's bourse and had a practical function to enable merchants to meet and conduct business. It had an unfortunate history, the first building of 1570 being burned down in the Great Fire of 1666. The second building, opened in 1669, was destroyed by a fire in 1838. The present, highly ornate building, designed by Sir William Tite, the third on site, was opened in 1844 by Queen Victoria. The Exchange abandoned its original function and is now offices and shops.

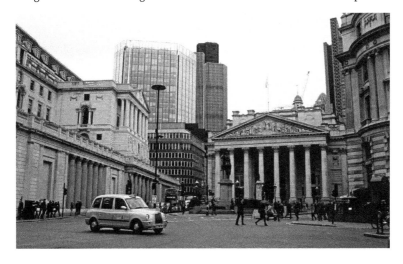

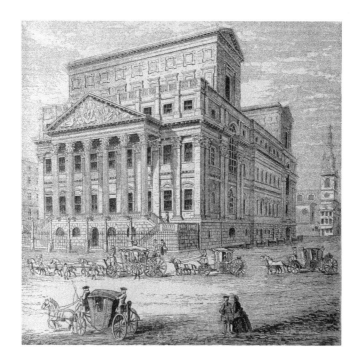

Plans for the Mansion House were accepted in 1735, adopting a Palladian design by George Dance, clerk of the City Works, who reported the edifice complete in 1752. It became the official residence of Lord Mayors during their elected year of office, although before that they had made do with their own residences, their livery company's hall or the Guildhall for big functions. This was the era of the most famous Lord Mayor ever, Dick Whittington (born around 1350 in Gloucestershire) and, legendarily, his cat, which is commemorated by a small statue on Highgate Hill, north London, where, again legendarily, Whittington heard the distant Bow Bells urging him not to give up but to return to seek his fortune. There are now ten principal rooms but looking at the old illustration, there were others – two high clerestory extensions, the Ball Room and the Banqueting Hall (known officially as the Egyptian Hall). These disproportionate extensions were humorously known as the 'Mayor's Nest' and 'Noah's Ark'. Unsurprisingly, they were subsequently removed amid the building's many later modifications.

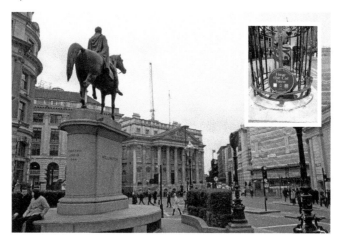

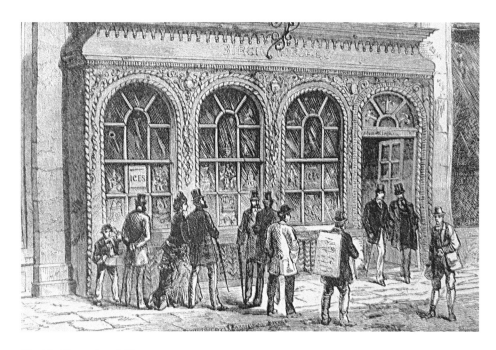

Birch's Shop, Cornhill

Alderman Birch, the 'celebrated Cornhill confectioner', took over the business at No. 15 Cornhill, opposite the Royal Exchange, in 1815 (apparently) according to the author of *Old and New London*. Birch was nicknamed 'Mr Pattypan' and sent, annually, a gift of a Twelfth Cake to Mansion House in traditional celebration of Twelfth Night. The author adds that the upper portion of the house at No. 15 was rebuilt but the 'curious specimen of the decorated shop front of the last century' survived. Birch died in 1840 having been succeeded in the Cornhill business by Ring and Brymer in 1836. The site was completely redeveloped in the 1920s but the distinctive shopfront was rescued by the Victoria and Albert Museum. This episode is typical of the massive changes wrought on the old, domesticated City by the increasing pace of commercial developments.

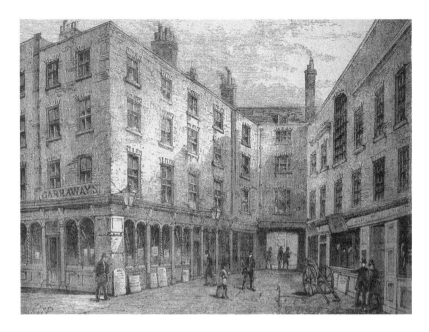

Garraways Coffee House Shortly Before Demolition

Garraways represents another historical City landmark that fell to Victorian progress. The old view has huge immediacy and captures the feel of a disappearing and more intimate aspect of the City's existence. Garraways, although special, was not unique. It was in coffee houses such as this that London's great commercial and trading ventures evolved as merchants and speculators met to imbibe coffee, the new craze of the seventeenth century. In the words of *Old and New London*, 'Garraways closed after a joyous existence of 216 years. As a place of sale, exchange and auction, and lottery, it was never excelled. Here tea was first sold and here the South Sea Bubblers met.' This is an allusion to the disastrous collapse of the South Sea Company in 1720 after frantic speculation. And, paradoxically, it was Garraways that '...first publicly sold the said tea in leaf, and drink made according to the directions of the most knowing merchants and travellers into those eastern countries'. Today, only a plaque survives of this history-shaping establishment.

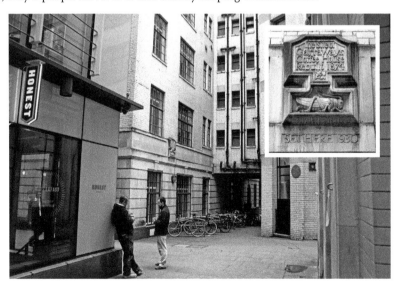

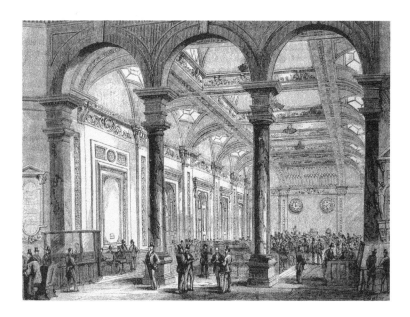

Interior of Lloyds

Lloyds of London is one of the great financial institutions that originated in a seventeenth-century coffee house – in this case, a small place in Lombard Street, 'kept by a man named Lloyd'. Lloyds underwriters gained world prominence in the business of marine insurance. Lloyds evolved into a unique insurance market that had no shareholders and accepted no corporate liability for the risks insured, these being carried by the underwriters themselves. Such is Lloyd's prominence that its trading traditions even became part of popular lore: Lloyd's List (of shipping) and, still hanging above the rostrum, the famous Lutine Bell, which used to be sounded at every reported loss of shipping. The old illustration conveys the relatively leisured atmosphere of Lloyds when it occupied premises at the Royal Exchange. In 1928, the ever-expanding Lloyds occupied new premises designed by Sir Edwin Cooper on the site of East India House, Leadenhall Street. A large, linked extension was built in the 1950s, designed by Terence Heysham. In 1979, Richard Rogers & Partners were commissioned to design an exciting, revolutionary new building to house the underwriting room, which has become one of London's architectural treasures.

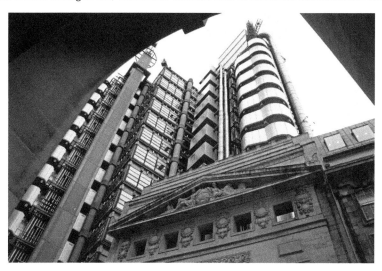

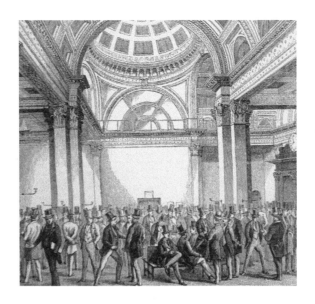

The Present Stock Exchange

The author of *Old and New London* marvelled that 'In a few hours property, including time bargains, to the amount of £10,000,000 has changed hands'. This figure is totally eclipsed by today's vast amounts – made possible by the growth of the world economy, deregulation in the 1980s and increasing globalisation. With IT, the speed of transactions is infinitely greater than Victorian traders could have predicted. Historically, an international conference in Washington, 1884, decided that the prime or zero meridian would run through Greenwich. This gave London a huge advantage when it came to twenty-four-hour trading across the globe. Joint stock companies evolved from the mid-sixteenth century and, by the late seventeenth century, many brokers trading in stocks and shares flourished in London – characteristically meeting at Garraways Coffee House, to give one example. The Exchange occupied various premises, moving in 1972 to the rather squat tower block visible behind the Bank of England in the previous illustration. Two big events in 2004 created the present astonishing image – the Exchange moved to new premises in Paternoster Square where the stones of old Temple Bar were re-erected next to St Paul's.

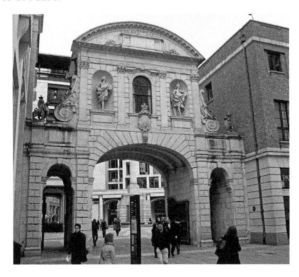

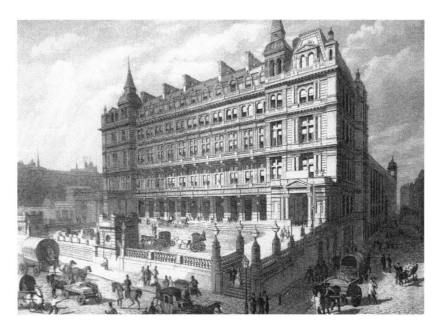

Cannon Street Railway Station

Cannon Street station, designed by John Hawkshaw, opened in 1866 as the City terminus of the South Eastern Railway, the massive development bridging the Thames to provide central access for thousands of daily commuters. The station was roofed by a spectacular steel arched roof, 106 feet high at the apex. This was damaged by enemy bombing in the Second World War and finally removed in 1958. The palatial Cannon Street Hotel, designed by E. M. Barry, was added between station and street in 1867. The station and hotel changed completely in the 1960s onwards after the construction of various office blocks to maximise railway revenue. After planning permission in 2007, the ugly blocks were replaced with a more aesthetically pleasing mixed-use commercial and retail design by Fogo Associates. Only the distant Gothic tower (one of a pair at the north end of the Thames bridge) visible in the background (right) hints at the station's Victorian ancestry.

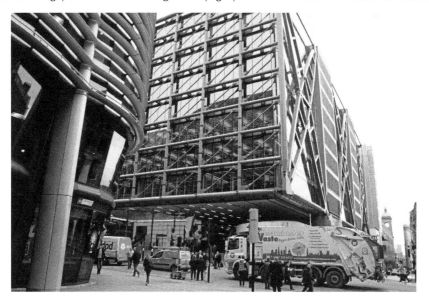

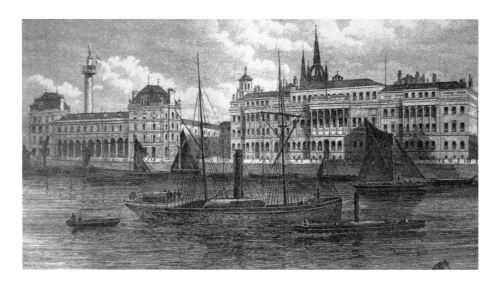

New Billingsgate Market

The new Italianate market hall designed by Sir Horace Jones (also responsible for Smithfield Market) was opened in 1877. There had, however, been a dock here since Anglo-Saxon times, trading in various cargoes but, as the medieval era progressed, specialising in the vital commodities of 'coal, corn and salt'. Not until an Act of 1698 did Billingsgate become the more familiar '...free and open market for all sorts of fish whatsoever...' (Manton & Edwards, 1989). In Victorian times, fish still arrived by boat from the Thames Estuary or the North Sea. However, the combined effects of industrial river pollution and the coming of the railways drove change. Fish arrived in bulk by train at the London termini from the northern fishing ports and on to Billingsgate by horse wagon. In 1981, reacting to the impossible congestion of Lower Thames Street, the market moved east to the Isle of Dogs. The same view today shows not fishing boats but a museum ship, the Imperial War Museum's historic battle cruiser HMS *Belfast*, launched in 1938. The slender column of 'the Monument' in Pudding Lane is just visible on the left, above the market building. This marks where the Great Fire started in 1666.

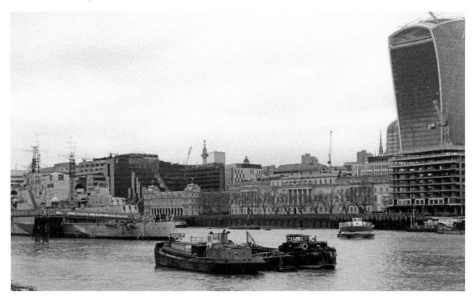

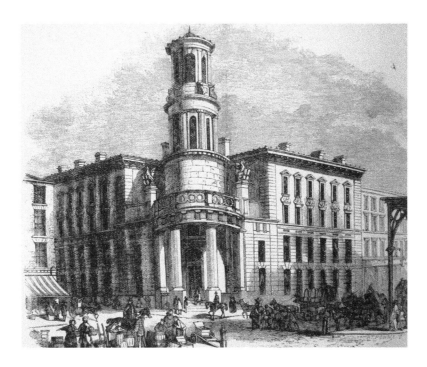

The Present Coal Exchange

This fascinating and imaginative building of 1849, formerly standing in Lower Thames Street, was designed by J. B. Bunning and was appropriately decorated with coal motifs by Frederick Sang. The wooden floor was inlaid with the shape of a mariner's compass and a wind dial helped coal dealers to estimate the time of arrival of coal shipments. Rising above the trading floor were three tiers of balconies of decorative ironwork and the dealers' offices. Architecturally, the exterior profile was imaginatively surmounted by a glass dome. Against considerable protest, the Exchange was demolished in the 1960s, a period which also saw the controversial demolition of another significant Victorian structure, the Euston Arch in North London. The Victorian Billingsgate Market Hall, however, still stands opposite – although vacated by the fish trade – and is now a conference and exhibition centre.

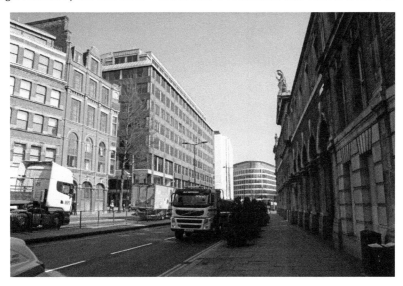

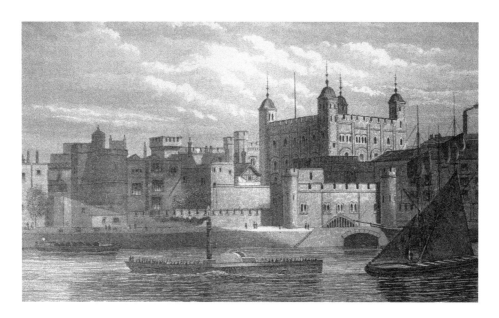

The Tower of London

As is well known, the Tower was built by William I to fortify London shortly after the Norman conquest of England in 1066. To the author of *Old and New London*, 'The Tower has been the background of all the darkest scenes of English history.' This truism opens up too many avenues to explore in detail but there are some interesting Victorian dimensions to the Tower that are relevant today. The popular superstition, enthusiastically related by tour guides, that Britain will fall if the resident ravens ever leave the Tower is questioned by Roud. There appears to be no record of the ravens in the Tower records before the mid-nineteenth century. More than that, the earliest reference that one researcher could find that Britain will fall if the ravens leave is as late as 1955. Roud concludes that this may even be tourist lore, a tale invented by guides to 'spice up' the visit! (Roud, 2008). The Victorian view from across the Thames has a medieval air about it but the modern steel bulk of HMS *Belfast* now dominates the river too.

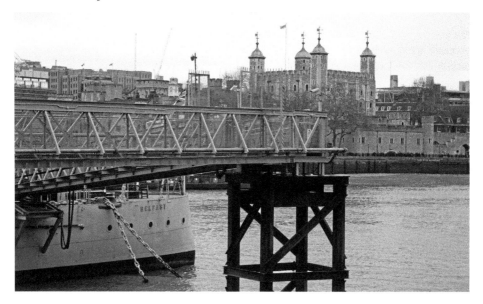

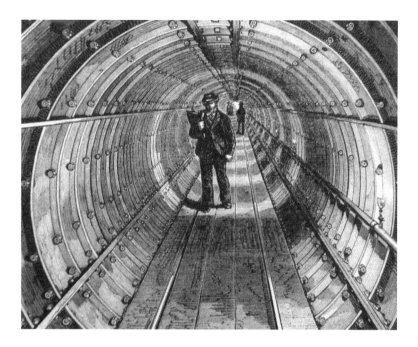

The Tower Subway

There is very little awareness today of this particular route under Thames adjacent to the Tower of London, largely because the tunnel is no longer open, although remaining in use to contain essential services, water mains. The subway is historically significant, though. Constructed in 1869 by P. W. Barlow, the project also involved J. H. Greathead's engineering expertise – the early use of the so-called Greathead 'tunnelling shield', capable of boring through the London clay at deep level, valuable experience for boring tunnels for London's later 'tube' trains. A cable-hauled passenger tram service was planned but, in practice, a rather claustrophobic foot tunnel was adopted. The tunnel closed in 1896 soon after Tower Bridge opened in 1894. This bridge, engineered by John Wolfe-Barry with, again, Sir Horace Jones as architect, is a Victorian contradiction, deliberately Gothic in appearance but technically sophisticated in function. The twin bascules could be raised hydraulically to enable ships to safely sail beneath.

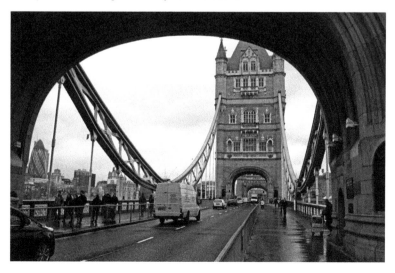

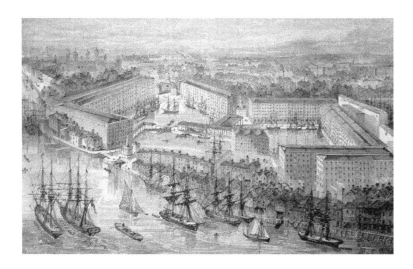

St Katharine Docks

St Katharine Dock (and the spelling seems to vary) was one of the earlier of the great enclosed docks that expanded eastwards as London's seaborne trade increased dramatically from around the end of the eighteenth century. St Katharine Dock, built conveniently close to the City, just east of the Tower, was one of the solutions. Firstly, though, the site had to be cleared, whatever the consequence for inhabitants – a story that repeated itself with London's other great urban and river improvements. The medieval Church and Hospital of St Katharine were cleared ('religion elbowed off by commerce') together with over 1,000 packed dwellings. Taking over two years to construct, the docks were opened in 1828 but were handicapped by the relatively narrow entrance lock. St Katharine was finally closed in 1968 and extensively redeveloped. The so-called 'Ivory House', added in 1858 (a secure warehouse for precious ivory imports), survives today and is distantly visible across the Thames, behind the volunteer litter pickers.

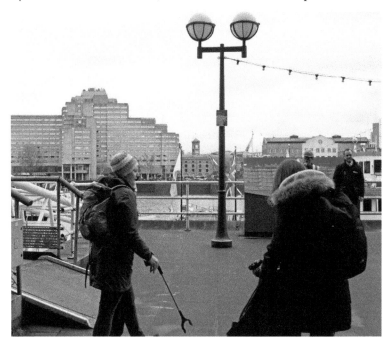

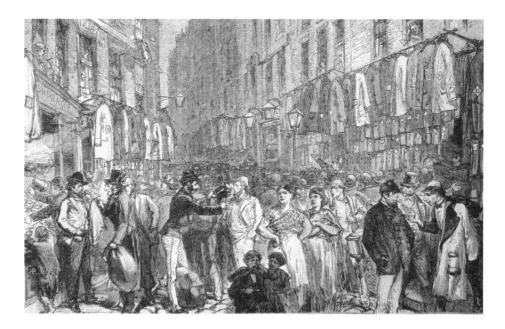

Petticoat Lane

Petticoat Lane is perhaps the most famous of London's many street markets, although marked on modern maps as 'Middlesex Street'. The oft-repeated wisdom that Victorian prudishness could not tolerate the old name, probably derived from the sellers of old clothes who concentrated there, seems to be contradicted by the illustration, captioned 'Petticoat Lane', published in *Old and New London*. This was one of the largest of the Victorian street markets and offered not only clothes but all kinds of goods. After street widening in the 1900s, the market expanded and attracted huge crowds on a Sunday morning. The authorities tried to stop this, even driving fire engines through the crowds. An Act of 1936 finally legalised Sunday trading. In practice, the market spread into surrounding areas and opened every day of the week, evidenced by the weekday scene in Wentworth Street and the sign above.

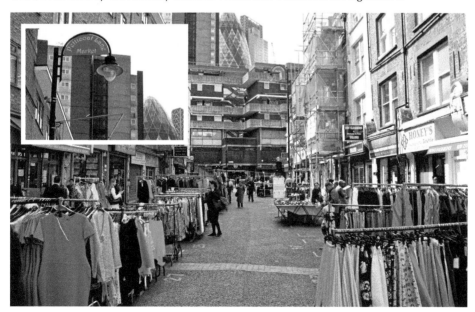

Westminster and the Western and Northern Suburbs

LONDON.

WESTMINSTER AND THE WESTERN SUBURBS.

"I began to study the map of London."—R. Southey.

IN the first two volumes of this work we have dealt with the antiquities, the buried history, the traditions, the folk-lore, and the anecdotes of what we may term the eastern hemisphere of London, and if a like success can be achieved in our treatment of the corresponding world which lies west of the above-mentioned line, we shall have accomplished a task of no ordinary difficulty. With the world of Westminster and its surrounding districts—the "old court suburb" of Kensington, Chelsea, Marylebone, and the suburban regions of Lambeth, Bayswater, and Hampstead—we have henceforth to discharge the duty of a topographer and a chronicler in one, describing their features, "old and new," pointing out the spots which they contain rendered sacred by old traditions and haunted by ancient memories, and contrasting their present with their former state. In the performance of this pleasant task, we shall indeed be much wanting to our subject and to the public too, if we cannot wake up again into life and being the ghosts and the shadows of

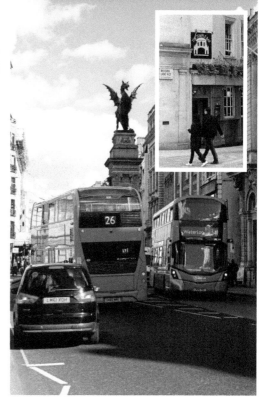

Temple Bar

Temple Bar marked the City's ancient western boundary – Westminster, the royal palaces and Parliament lie beyond, to the west. By custom, the monarch asks permission of the Lord Mayor to enter the City. The Lord Mayor offers the sword of state as a demonstration of loyalty. The sword is immediately returned and borne in front of the procession through the City to demonstrate that the monarch is under the Lord Mayor's protection. Temple Bar was rebuilt in Portland stone by Wren in the 1670s. In that harsher time, the heads of executed traitors were displayed as an awful reminder of the penalty of treason. Temple Bar became an obstruction and, during 1877–78, it was removed and eventually re-erected on the estate of Sir Henry Bruce Meux at Theobalds Park, Cheshunt but was returned to the City and rebuilt next to St Paul's in 2004. A memorial marks the old site now and a local pub sign depicts the appearance of Temple Bar itself.

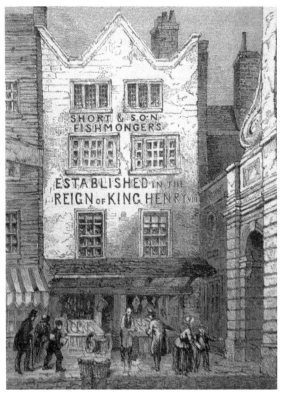

The Old Fish Shop by Temple Bar

The Old Fish Shop was situated on the north side of the Strand, immediately adjacent to Temple Bar. It proudly claimed to have been established in the reign of Henry VIII and represented one of London's many medieval survivals that were swept away by Victorian progress. The shop would have served a large local residential population. It was demolished shortly after the drawing was made in 1846 to make way for the massive new Law Courts. The Temple Bar Memorial overlooks the site where the shop once stood, now dominated by the Law Courts. The memorial was designed by Sir Horace Jones in 1880 and surmounted by a bronze heraldic griffin, emblematic of the City, by Charles Birch.

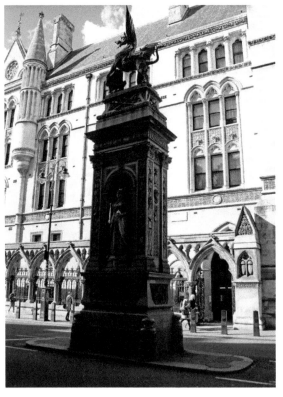

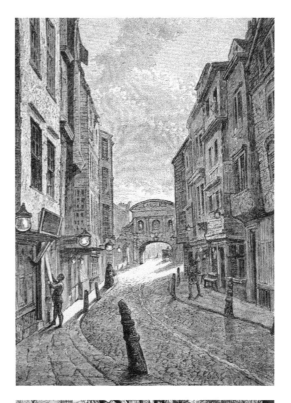

Butcher's Row in 1800

The tall, narrow and densely packed old buildings of Butcher's Row survived long enough into the nineteenth century to become of antiquarian interest. No trace remains but, as the view shows, it ran to Temple Bar from the northern side of the Strand. Butcher's Row even gained some infamy as it was associated not only with crime in general but it also appeared that the infamous Guy Fawkes and other members of the so-called Gunpowder Plot met here to plan their attempt to blow up Parliament in 1605. The dense mass of buildings also obstructed and obscured the route to the parish church of St Clement Danes in the Strand. Alderman Picket, who campaigned vigorously to have such poor, overcrowded areas cleared, finally succeeded in this case in the early nineteenth century.

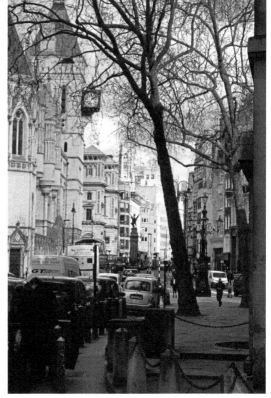

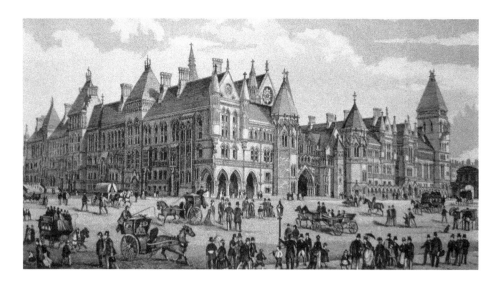

The New Law Courts

The Royal Courts of Justice, or 'the Law Courts', were another necessary development as Victorian London grew in scale and complexity. The intention was to centralise all the superior courts administering civil cases (not criminal), which had been traditionally heard in Westminster Hall. G. E. Street was appointed as the architect. The foundations were laid in 1871–72 and work began on the building proper in 1874. Six years were allowed for completion but labour, financial difficulties and bad weather delayed the royal opening by Queen Victoria until 1882. The architect had previously died in 1881, the cause being generally attributed to the strain of the delays. Another inevitable price of the project was the eviction of many poor people by the clearances necessitated by the building. Each November, the newly elected Lord Mayor arrives in procession at the courts to be sworn in by the Lord Chief Justice. The Lord Mayor's coach, richly decorated and made in 1757, is permanently on display at the Museum of London, apart from during this annual event.

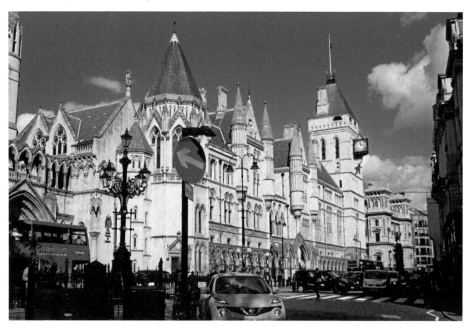

Lincoln's Inn Gate, Chancery Lane
Lincoln's Inn Gate in Chancery Lane is one of London's unchanging monuments amid all the Victorian improvements and modern development. Lincoln's Inn is one of the four Inns of Court, founded in the mid-fourteenth century and possibly named after Thomas de Lincoln, the King's Serjeant of Holborn. Lincoln's Inn appears in Charles Dickens' *Bleak House*, 'At the very heart of the fog, sits the Lord High Chancellor in his High Court of Chancery'. (Dickens, 1970). This passage alludes not only to a characteristic of London's weather (fog) but also seeks to convey the murkiness of the law, one of the author's recurrent critical themes. Two eminent Victorians, who both rose to be prime minister, Benjamin Disraeli and William Gladstone, enrolled as students in 1824 and 1833 respectively.

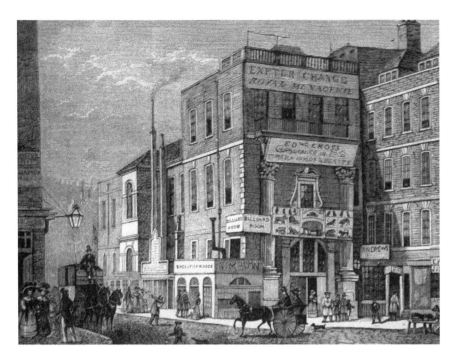

Exeter Change

This extraordinary building, remembered by older Victorians, was built in around 1676 and stood in the Strand. It was the scene of some extraordinary events. Edward Cross established his menagerie here – lions, tigers and monkeys – which apparently flourished from 1773–1829. In 1826 there was even an elephant in the collection, Chunee, who attempted to break out of his cage. The attendants tried to shoot Chunee but failed, so troops were called in to dispatch the maddened beast but they too failed. A keeper, however, saved the day by resorting to a harpoon and finishing off the unfortunate Chunee. Apparently without conscience, Cross put the animal's skeleton on display after it had been flayed and dissected. When the building was demolished in 1829, the menagerie was transferred to the Surrey Zoological Gardens.

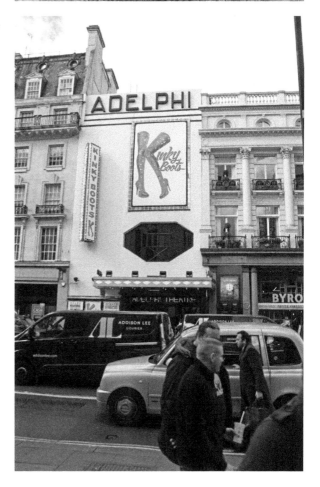

The Old Adelphi Theatre

Parts of the Strand and adjacent streets are distinguished by their many theatres or, in today's marketing terms, this is 'Theatreland'. The Adephi was opened in 1806 as a vehicle for his actress daughter and was originally named 'Sans Pareil'. In 1821, William Moncrieff's dramatisation of Pierce Egan's *Tom and Jerry or Life in London* enjoyed a long run. Similarly, popular dramatisations of Charles Dickens's novels attracted audiences during the period 1837–45. The theatre was rebuilt by Ernest Schaufelberg in 1930, opening with a C. B. Cochran production, *Evergreen* (*The London Encyclopaedia*, 1983). It is perhaps tempting to conjecture what that generation of theatregoers would have made of today's production, *Kinky Boots*.

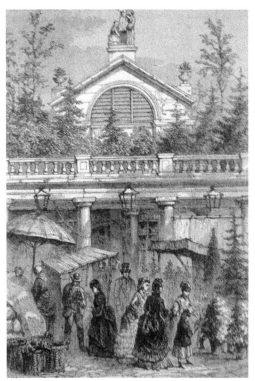

Entrance to Covent Garden Market

In great contrast to today's upmarket shopping, dining, entertainment and meeting venue, Covent Garden Market was once London's most famous flower and vegetable market. It started in 1656 with a few temporary stalls and was licensed by Charles II in 1670. An Act was passed in 1828 for the market's stricter regulation and a new market hall, which largely survives, was built by Charles Fowler. This became the place that 'society' enjoyed mixing with farmers and flower girls, characterised by Eliza Doolittle in George Bernard Shaw's play *Pygmalion*. It was eventually accepted that this was not the place for a fruit and vegetable market today and the trade moved to new premises at Nine Elms, Battersea, in 1973. One of the features of Covent Garden is the street entertainers. In Victorian London, for example, Henry Mayhew recorded a rather mournful 'Punch and Judy Man'. Today's jauntier equivalent is the Harry Potter impersonator.

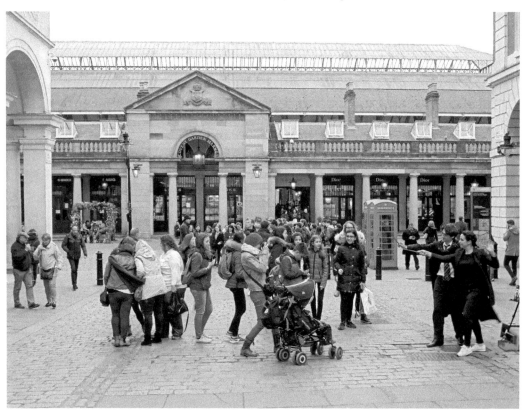

The Old Coachmaker's Shop in Long Acre

Just to the north of Covent Garden lies Long Acre, another much-changed district that is marketed today as 'Theatreland'. The scene in the nineteenth century was completely different. Long Acre was a manufacturing centre, including furniture and cabinetmaking. In the eighteenth century, Thomas Chippendale's workshop was here. Perhaps even more significantly, George Dodd identified Long Acre as 'a bazaar for coach-makers' and 'coach-making operations form the most remarkable feature in that street'. Many of the coaches and vehicles visible on the city's thoroughfares in the Victorian engravings of this book could have been designed and manufactured in Long Acre where, 'Out of about a hundred and forty houses that the street contains, more than fifty are occupied either by coach-makers, so designated, or by manufacturers of the lamps, fringe, harness &c. for coaches'.

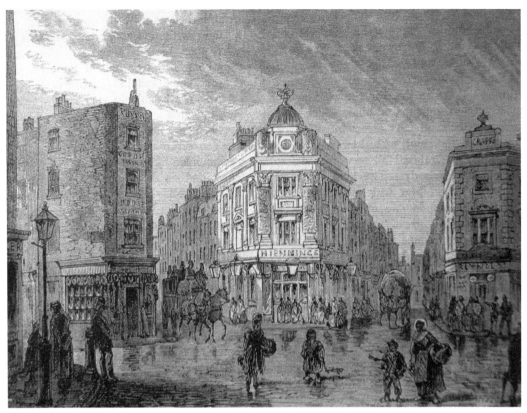

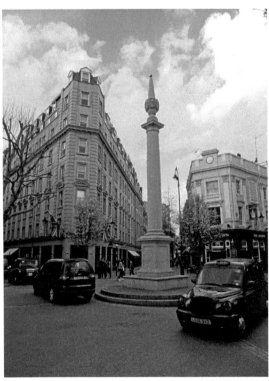

Seven Dials From an Original Sketch

Seven Dials lies close to Long Acre, up St Martin's Lane. Again, it is today a part of that modern marketing concept of 'Theatreland' but was a very different place in the Victorian era. Charles Dickens describes what a stranger to 'The Dials' might find: '... the entrance of seven obscure passages, uncertain which to take, will see enough around him to keep his curiosity and attention awake...' Dickens describes the dirt, 'unwholesome vapour' over the housetops and people 'lounging at every corner', as if there to 'take a few gasps of fresh air', although difficult to achieve. His account then focuses on two ladies who had imbibed too much 'gin-and-bitters' and were squaring up to settle their differences ('Seven Dials' *Sketches by Boz*, 1839). Although the area is much altered and pleasant to explore, at least some of the Victorian atmosphere survives (if not the fighting).

The 'Rookery', St Giles's

'Rookery' was the old term for those close-packed and insanitary districts that suffered from gross overcrowding, but for much of the Victorian era there was no alternative. Cheap fares to outlying districts of less expensive accommodation helped, and so did the more affordable blocks of model dwelling houses erected in enlightened central districts. Another example of 'the problem of the poor' was the notorious St Giles's area. *Old and New London* explains that this 'colony' was called either 'The Rookery' or 'Little Dublin' 'on account of the number of Irish who resided there', indicative of Victorian London's attraction to immigrant communities as a source of work and also the impossibility of housing everyone. There were even houses of fifty beds inhabited by a 'floating population of 1,000 persons who had no fixed residence, and who hired their beds for the night...' The driving of New Oxford Street through the area in 1847 dispersed these unfortunates but did not solve the housing problem.

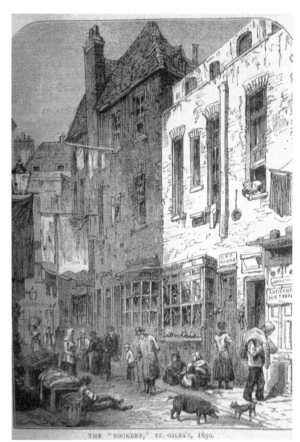

THE "ROOKERY," ST. GILES'S, 1850.

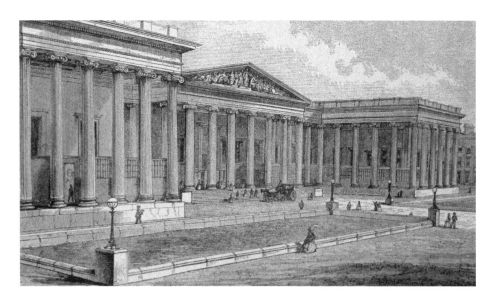

The Front of the British Museum

The British Museum opened to the public in 1759 but only by ticket and for three hours a day. The basis was the collection of Sir Hans Sloane (who died in 1753), which the government had purchased. The original premises were at Montagu House. Early acquisitions included the Rosetta Stone and the so-called Parthenon Marbles, purchased and brought back from Greece in somewhat controversial circumstances – a hot topic today as museums debate the ethics of 'cultural restitution'. The museum was extensively developed by Robert Smirke, who planned a quadrangle and open courtyard behind Montagu House, which was progressively subsumed into the grand concept. The new classical Greek façade and portico was commenced in 1842 and makes a huge impact today, approached from Great Russell Street – 'A museum of the world for the world'.

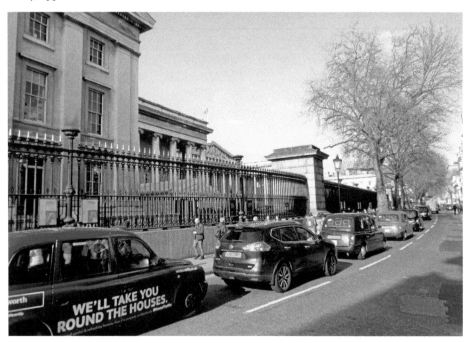

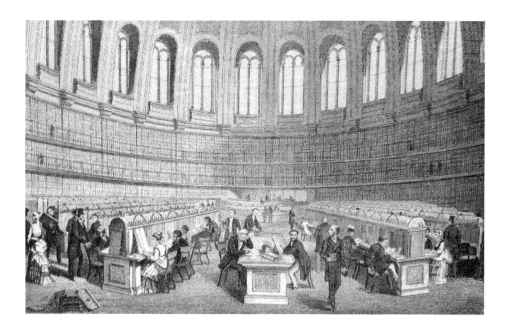

Reading Room in the British Museum

Sir Anthony Panizzzi, appointed Principal Librarian of the Museum in the 1850s, had an idea for a grand reading room. From 1852–57, the courtyard was converted into the Reading Room designed by Sydney Smirke (brother of Sir Robert Smirke). The impressive dome of the Reading Room was one of the largest in the world. Many scholars and writers used the Reading Room including Karl Marx, who researched his famous work, *Das Kapital*, originally published in 1867. Marx, who lived at several addresses in London, died in 1883 and was interred at Highgate Cemetery. In recent years, the reference collection was moved to new, purpose-built accommodation in the Euston Road – the British Library. The former Reading Room has been used by the museum as a temporary exhibition gallery.

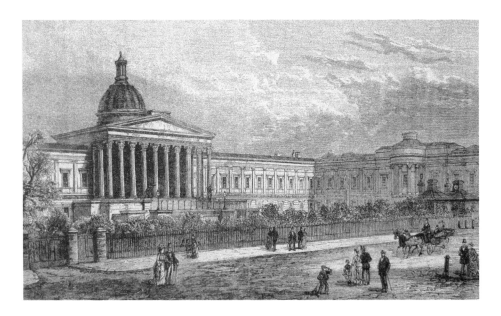

University College, Gower Street

This fine classical building lies a few minutes walk from the British Museum, up the architecturally satisfying and still largely Georgian Gower Street. Significantly, the college was founded in 1826 with a policy of religious toleration. The moving forces behind the new college were Lord Brougham, Thomas Campbell and James Mill, who wanted to provide a university education for non-Anglicans who were then excluded from England's ancient seats of learning, Oxford and Cambridge. It received its charter in 1836 – although its critics condemned it as 'godless' – and the main building was completed in 1829, designed by William Wilkins, the architect of the National Gallery in Trafalgar Square. University College was incorporated into the University of London in 1907 and currently aims to be a world institution. Saving the environment seems to be a current student issue.

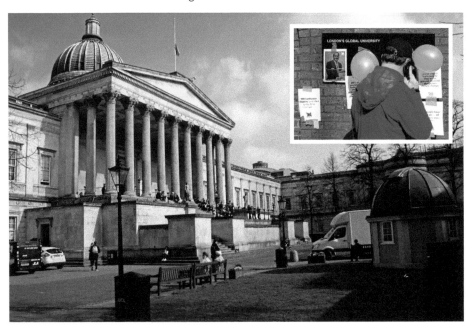

Northumberland House

A walk down the Charing Cross Road gives access to the National Gallery, Trafalgar Square and the site of the old Northumberland House in the Strand. From here, the Thames is not far away. The present view is taken from just in front of the National Gallery, founded in 1824, and Nelson's Column, finished in 1843, is visible on the right. Northumberland House was demolished in 1874 to construct Northumberland Avenue, which runs down to the Victoria Embankment. This grand mansion was built at the beginning of the seventeenth century for the Earl of Northampton. It became surrounded by shops and commercial premises in the mid-nineteenth century. Its destruction demonstrates that it was not just rookeries that were demolished by the Victorians in the name of progress.

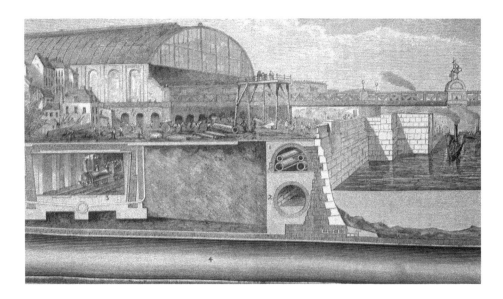

Section of the Thames Embankment, 1867

The illustration represents a section, taken at Charing Cross railway station, of Sir Joseph Bazalgette's ambitious scheme to embank and to contain the River Thames and to solve the increasing problem of managing London's sewage. The Thames had become increasingly polluted as the old sewers, running at right angles to the Thames, emptied directly into the river. The Great Stink of 1858 even brought proceedings in the Houses of Parliament to a standstill, so overpowering was the stench. Bazalgette's solution was huge in scale but essentially simple in concept. Three lines of new intercepting sewers, high, medium and low, took the effluent downstream. Gravity provided the momentum but, additionally, sewage pumping stations were built far to the east at Abbey Mills on the north bank and Crossness on the south. This tremendous achievement brought the Thames under better control, disposed of London's sewage and eliminated cholera epidemics. It was said that Bazalgette's scheme, commenced in 1868 and completed in 1874, saved more Londoners' lives than all the doctors in the city. The 'pneumatic railway', incidentally, was too ambitious even for Victorian ingenuity.

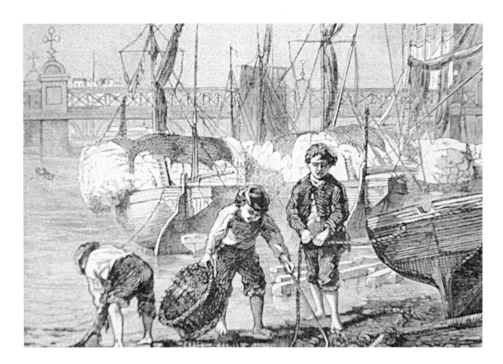

On the Thames at Low Water

One of the great trials for the poor in Victorian London was to find somewhere affordable to live. Another was to find a means of earning enough money to survive. Henry Mayhew described the desperate measures to which many Londoners took just to earn a little money. Some even penetrated the sewers, sifting for scrap metal or other finds that could be sold. Another possibility was to comb the river banks, searching for 'finds' that might be of value. These 'mudlarks' survive today, although they now use metal detectors and even find real 'treasures'. This London tradition is commemorated by the Mudlark pub, just west of the south end of London Bridge, close to Southwark Cathedral.

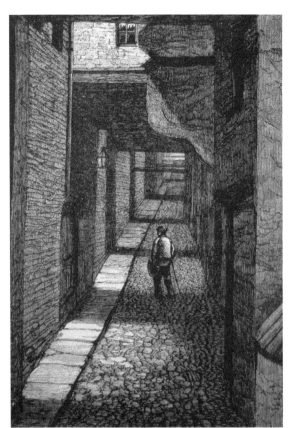

Ivy Bridge Lane

Sir Joseph Bazalgette's scheme was a triumph of public health engineering that saved countless lives. His monument stands on the Embankment. The project was not without its human costs, however. Before embankment, the low-lying riverbanks were covered with mazes of alleys and densely packed dwellings. As with all these massive schemes, thousands of people lost their accommodation. No recompense was available in that laissez-faire era. Ivy Bridge Lane, south of the Strand, was one such alley that disappeared under the construction of the Victoria Embankment. It is recorded that in 1847 it led to Ivy Bridge Pier where Thames steamers could be boarded. It is tempting to wonder whether the office workers, enjoying the early spring sunshine on the ornate seats, could even imagine what once existed far below today's pavement level.

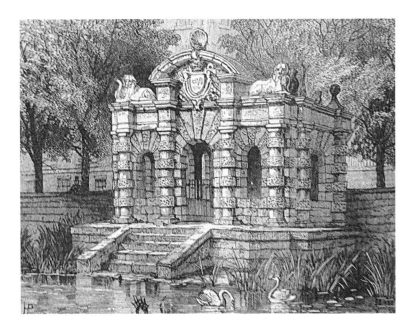

Buckingham Gate in 1830

This old view helps to clarify the huge changes that the construction of the Victoria Embankment represented. A grand mansion, York House, once stood in this area. Here, in the seventeenth century, lived the Duke of Buckingham. The Duke fell into debt and sold off the house but made it a condition that his name and titles should be kept in memory by the streets built upon it – hence the name of the old stone water gate that once gave access to the Thames. Buckingham Gate, the only vestige of the former mansion, survives in Embankment Gardens, although, after the construction of the Embankment, it now stands some distance inland from the Thames bank.

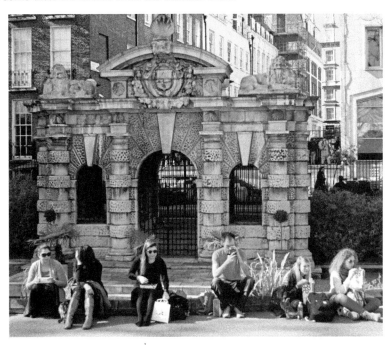

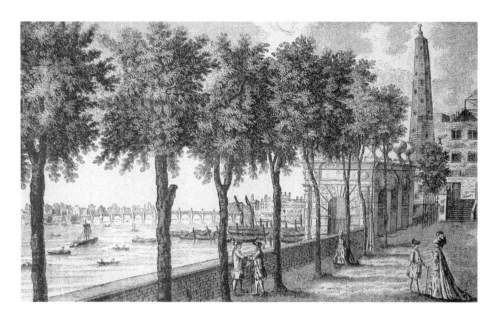

York Stairs and Water Tower from a Print Dated 1780

The area where the Duke of Buckingham's mansion once stood never really lost its name of York House and the water gate continued to be known as 'York Stairs'. As the old print depicts, a tall and rather inelegant wooden tower was built here in the 1690s, around 70 feet high and with windows to light the interior. Its function was to raise water from the then relatively unpolluted Thames and to supply fresh water to the surrounding properties of the Strand. The present view is deceptive: the land, after the construction of the Embankment, effectively advanced into the Thames, narrowing its course. The Georgian couple in the present scene are actually walking along a line that would have been well inland in the eighteenth century. The costumed figures themselves appeared on the Embankment by chance during photography.

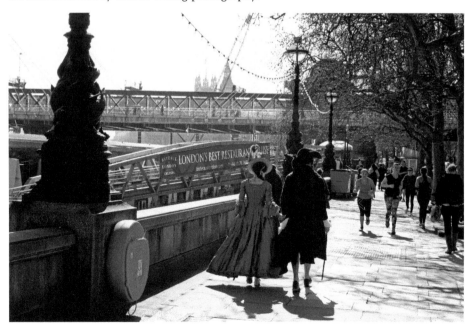

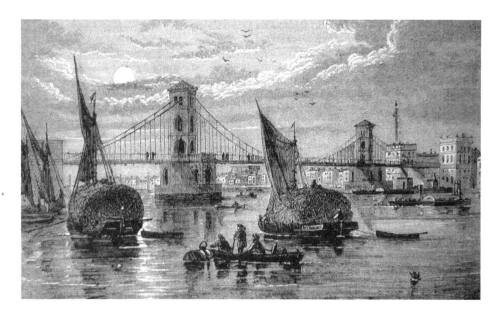

Hungerford Suspension Bridge

It is perhaps surprising to learn that the Thames was once spanned by a narrow suspension bridge designed by Isambard Kingdom Brunel and completed in 1845. It was built to serve the old Hungerford Market, which was demolished in 1860 to make way for Charing Cross railway station. The railway bridge (which incorporated a footbridge) across the Thames carrying the line to Charing Cross station was designed by Sir John Hawkshaw and completed in 1864. This replaced Brunel's earlier Thames Bridge. The bridge's suspension chains were transported to Bristol and utilised to complete Brunel's suspension bridge across the Avon Gorge. The present view shows the London Eye and 'Cleopatra's Needle', an ancient obelisk shipped from Egypt in a special pontoon and erected in 1878.

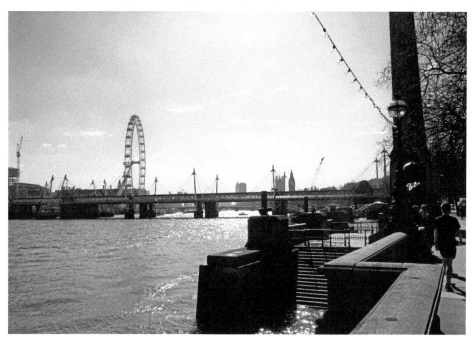

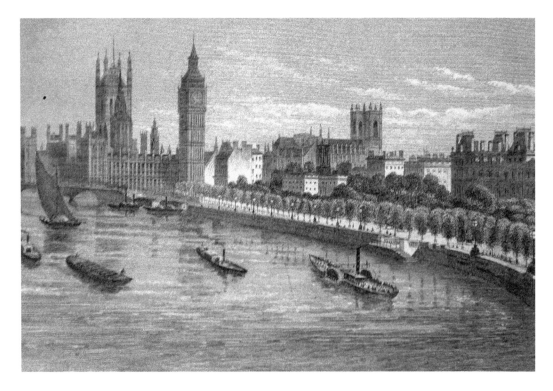

The Thames Embankment

This scene shows the grand sweep westwards of the Victoria Embankment towards Westminster Bridge, the Houses of Parliament and Big Ben. An impressive but familiar sight to Londoners today, it would have looked startlingly new in 1878, the year of publication of *Old and New London*. These structures, so much a part of London's character today, had barely been completed. The Embankment functioned as a major highway between the City and Westminster and, as the earlier sectional view shows, also accommodated the underground railway, today's District and Circle lines.

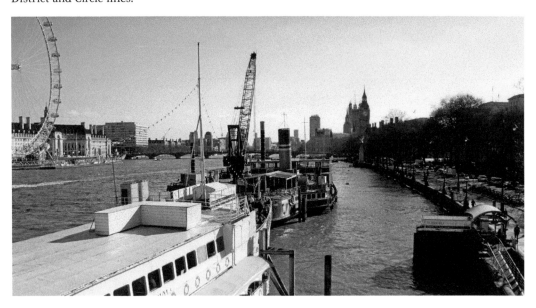

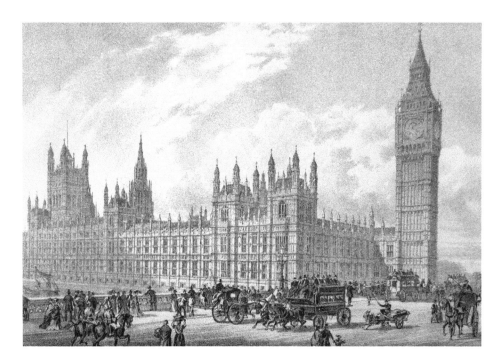

The Houses of Parliament from Westminster Bridge

The present Westminster Bridge is of cast iron and consists of seven arches. It was completed in 1862 by Thomas Page with Sir Charles Barry, architect of the new Houses of Parliament buildings. It replaced an earlier bridge of 1750, the second masonry bridge to span the Thames in London. It was from the parapet of this earlier bridge that William Wordsworth famously observed that 'Earth has not anything to show more fair'. In shocking contrast, on the day following the taking of the photograph, a murderous outrage was committed. As the *London Evening Standard* reported at the time under the headline 'London Attack ... terror strikes in the heart of Westminster' and 'Four people including police officer Keith Palmer were killed in London's bloodiest terror attack since 7/7'. A week later, Westminster Bridge was as busy as ever, many people pausing to pay their respects at the floral tributes to the victims placed along the parapets.

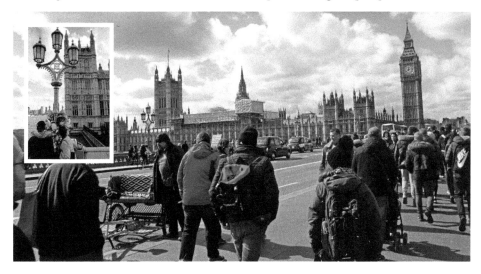

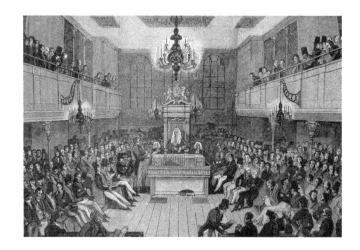

Interior of the House of Commons 1834 and 1875

The old Parliament survived the Gunpowder Plot of 1605 but the buildings burned down in 1834 after a fire was accidentally started within. *Old and New London* depicts the apparent rediscovery of Guy Fawkes's cellar, where barrels of gunpowder were concealed by the plotters. Ironically, it was the odd decision to carelessly secretly burn the useless old wooden tally sticks (which had been used in an archaic accounting system) in a furnace under the House of Lords that was responsible for the disaster. Thankfully, the medieval Westminster Hall was saved from destruction. The fire at least created the opportunity to rebuild Parliament in the Gothic style. Sir Charles Barry was appointed architect, assisted by Augustus Pugin in respect of the decorative details. The Chamber of the House of Commons was rebuilt with its traditional confrontational arrangement, very much as it had been before the fire of 1834. After an enemy air raid in 1941, the House of Commons was again reduced to rubble. Between 1945 and 1950, Sir Giles Gilbert Scott rebuilt the Chamber more or less as it had been before and it has become well known through televised broadcasts of debates.

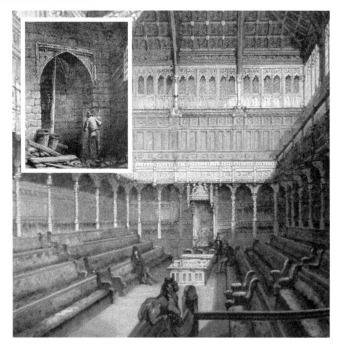

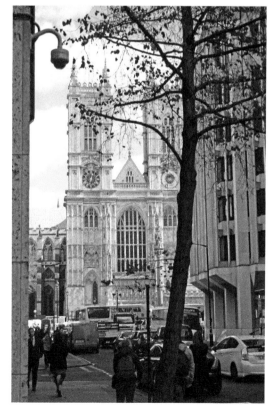

West Front of Westminster Abbey, from Tothill Street

The treasured religious symbols and venues for royal ceremonial and national events, St Paul's Cathedral and Westminster Abbey naturally survived the Victorian improvements and upheavals but, nevertheless, were changed by London's evolution into a modern world city. The sight of St Paul's from Ludgate Circus was partially blocked by a railway viaduct, as already commented. No such fate befell Westminster Abbey, which continued to dominate its surroundings. Modern developments – the view from Tothill Street, for example – seem to have diminished the abbey's presence, however.

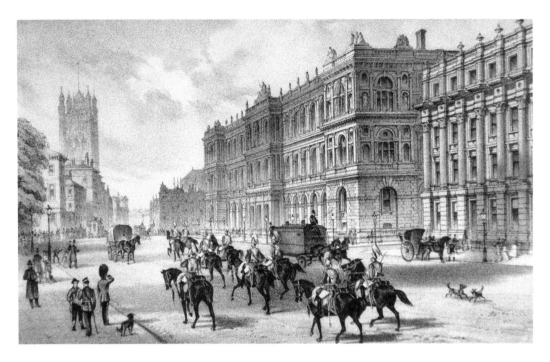

New Treasury Buildings

Increasingly, the buildings of Victorian government such as this were designed to impress – a measure of London as the focal point of British wealth, power and influence across the world. In the twenty-first century, security became an increasing concern, however. A comparatively recent measure was the installation of the iron the gates to protect, on the right of today's view, Downing Street and the Prime Minister's official residence at No. 10

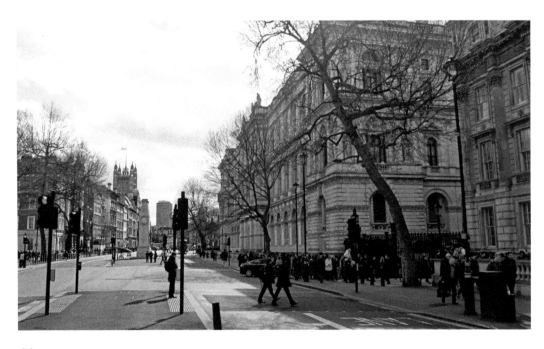

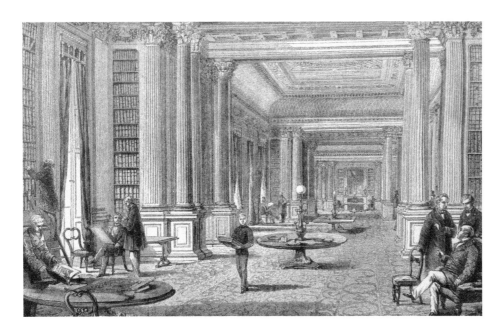

Library of the Reform Club

In the words of *Old and New London*, '...Pall Mall and the immediate neighbourhood of St James's have been for a century the head-quarters of those London clubs which have succeeded to the fashionable coffee-houses and are frequented by the upper ranks of society...' The Reform, situated in Pall Mall between the Carlton and the Athenaeum, was founded by radicals in the era of the passing of the Great Reform Bill in 1832, which extended the franchise, although only for better-off males of property. The building was designed by Sir Charles Barry in the Italian style. 'In an age of utilitarianism ... like ours, there is more to be learned here than in the ruins of the Coliseum, of the Parthenon, or of Memphis'. The present view shows the firm of Thomann Hanry cleaning the building's exterior.

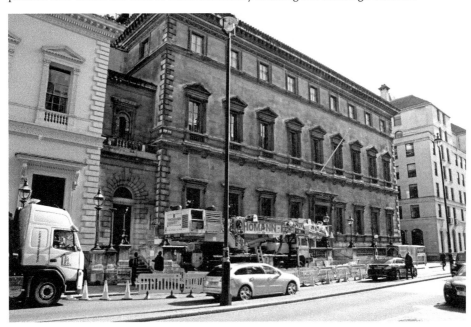

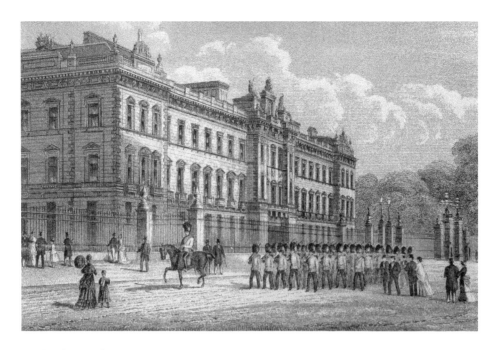

Buckingham Palace

When Queen Victoria ascended the throne in 1837, Buckingham Palace was in a very poor state of maintenance. John Nash's scheme had not really worked and he was dismissed in 1830. Edward Blore was subsequently appointed architect and he modified or altered Nash's works in important respects. Blore was responsible for designing the east front – a familiar sight today – facing The Mall. The project involved removing Marble Arch to its position at the north end of Park Lane. The east front was replaced in 1913 by the present Portland stone façade designed by Sir Aston Webb.

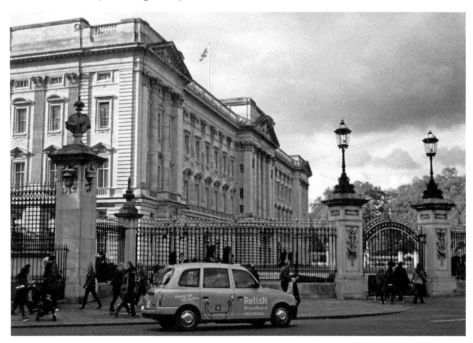

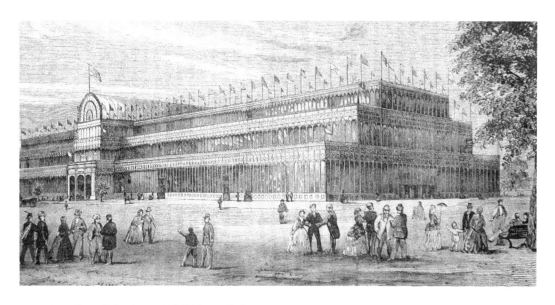

Exterior of the Great Exhibition of 1851

This epitome of Victorian imagination and practicality was the idea of Henry Cole and organised by a royal committee presided over by Prince Albert. Various locations across London were considered before Hyde Park was chosen. This provoked dismay in some quarters and the fear that it would attract undesirables to the park. Joseph Paxton won the competition to design the exhibition building. He based his ideas on the conservatory at Chatsworth where he was superintendent of the gardens. The prefabricated building of iron and glass proved a huge success. Exhibits – locomotives, carriages, agricultural machinery, church fittings – arrived from all over the world. The Great Exhibition was opened by Queen Victoria on 1 May 1851 and closed on 15 October of that year. Over 6 million people visited, an adventure made possible for the masses by the new railway network centred on London. The structure was transported to Sydenham and reopened as the 'Crystal Palace'. It burned down in 1936 but the site is worth visiting to view the life-size dinosaurs that were created in the 1850s.

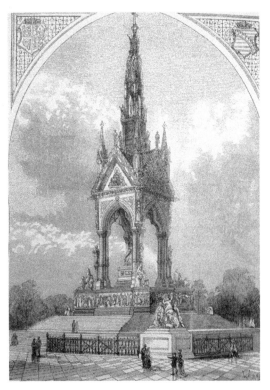

The Albert Memorial

It was regarded as a national tragedy when Prince Albert died from typhoid fever at Windsor in 1861. In 1862 a public meeting was held at the Mansion House by the Lord Mayor, William Cubitt, to discuss the raising of funds nationally for a memorial to the prince. Designed by George Gilbert Scott, the stonework of the elaborate memorial to Prince Albert was completed in 1872. The Gothic canopy reaches a height of 175 feet. In 1876, the 14-foot-high bronze statue of Prince Albert by John Foley was added. Fittingly, the prince holds the catalogue of the Great Exhibition, which he did so much to create and which formerly stood nearby.

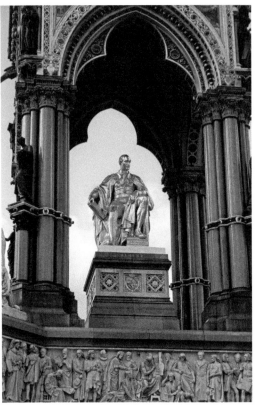

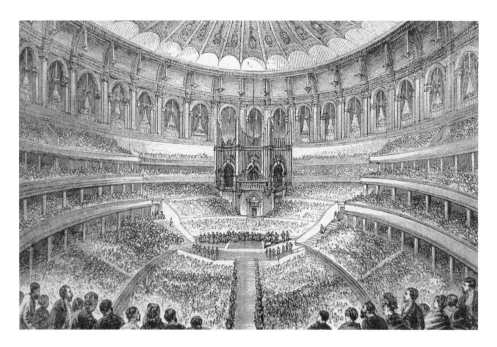

Interior of the Albert Hall

Prince Albert promoted the idea that, using the profits of the Great Exhibition, a large site in south Kensington should be purchased for the erection of schools, colleges and a central hall having libraries, a lecture theatre and exhibition rooms. The project proved difficult to finance but, after Prince Albert's death in 1861, the Commissioners of the Great Exhibition gave £50,000 and sufficient additional money was raised from the 999-year leasehold of seats. The design was by Captain Francis Fowke of the Royal Engineers, although he died before the hall's completion. Queen Victoria laid the foundation stone in 1868 and unexpectedly announced that the building's existing title, 'Hall of Arts and Sciences', should be prefixed with 'Royal Albert'. The hall's acoustics were not perfect but were improved in 1968 by suspending saucer-shaped baffles internally from the roof. The Albert Hall is nationally well known for the annual Sir Henry Wood's promenade concerts, 'the Proms'.

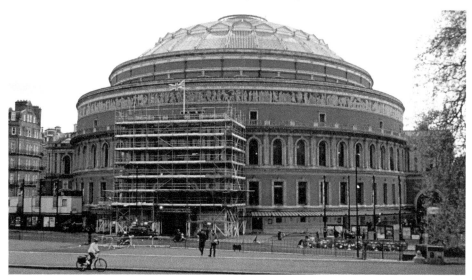

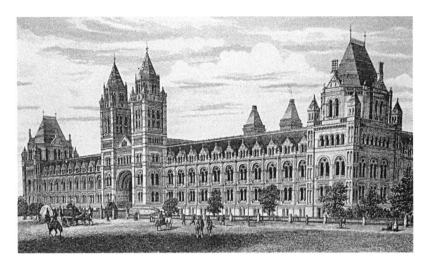

The Natural History Museum, South Kensington

The Natural History Museum, South Kensington, opened in 1881. Its origins, however, go right back to the government's acquisition of Sir John Soane's collection of natural history specimens and cultural artefacts and the opening of the British Museum, Bloomsbury, in 1759. Sir Richard Owen left his role as curator of the Hunterian Museum in 1856 to take charge of the British Museum's natural history collection. Among Owen's claims to fame was his invention of the name for dinosaurs (meaning, loosely translated from the Greek, 'terrible lizard'). Owen convinced the trustees that a separate building was essential to house the natural specimens. His efforts resulted in the building of the Natural History Museum. The architect was Alfred Waterhouse but Owen influenced the Gothic design, including the capacity to display large specimens such as dinosaurs and whales. Less well known is the museum's surprising role in Second World War, housing a secret Special Operations Executive (SOE) training and testing facility.

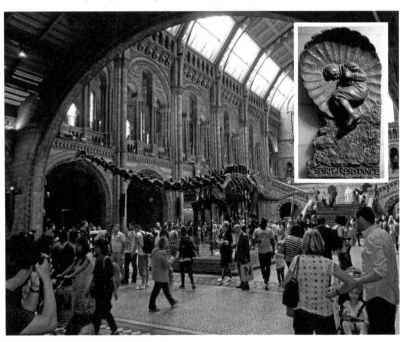

Piccadilly Circus from Coventry Street

To the north-west of Albertopolis, in the heart of Westminster, lies Piccadilly Circus, another of London's premier landmarks and meeting places. This area is devoted to theatres, restaurants and high-quality shopping. Piccadilly Circus was formed in 1819 by the intersection of Piccadilly with John Nash's new Regent Street, then in the course of construction. Architecturally, the area became less structured with the driving through of Shaftesbury Avenue. In the early twentieth century, the area became famous for the brightly illuminated advertisements fixed to the façades of many of the buildings. The iconic fountain, designed by Alfred Gilbert, arrived relatively late on the scene. The structure is, in fact, a memorial to the 7th Earl of Shaftesbury, a great philanthropist. The winged statue, unveiled in 1893, was intended to symbolise the angel of Christian charity and not Eros, the god of love. Today, there are street entertainers to be seen (including 'Charlie Chaplin') rather than the flower girls of the past.

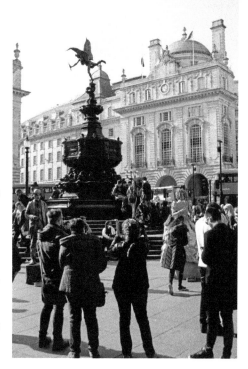

The Quadrant, Regent Street, Before Removal of the Colonnade

Historically, Regent Street had its origins in John Nash's ambitious plan to link Regent's Park to Carlton House, the Prince Regent's palace. The so-called 'New Street' was intended to raise London's profile to match the finest European capitals.

The central curved portion between Piccadilly and Oxford Street, the Quadrant, was planned to be the high point of the development with fashionable shops, colonnades of cast-iron columns and covered walkways. In *Shops and Shopping* (1989) Alison Adburgham decries the removal of the Nash's beautiful colonnade in 1848 as 'vandalism' and identifies the culprit as Frederick Crane, a local hosier and glover, the so-called 'father of Regent Street' who was motivated solely by misguided, narrow-minded trading considerations.

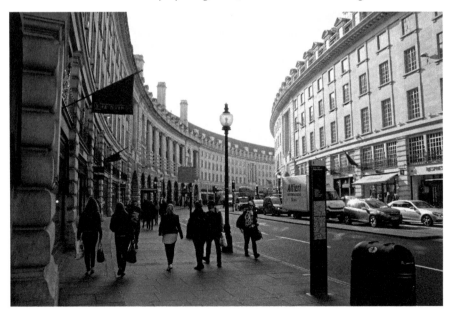

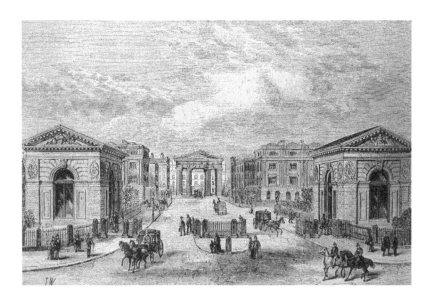

Entrance to Euston Square Station

Euston Square Station opened in 1838 as the principal entrance to the London and North-Western Railway Terminus, '...the greatest railway port in the world...What London is to the world, Euston is to Great Britain'. The first trains, however, had to be hauled by cable up to Chalk Farm because early locomotives were relatively low powered. The journey to Birmingham took five hours. The author of *Old and New London* described the terminal's entrance as a 'lofty and apparently meaningless Doric temple...which falls far short of the grandeur of the *Arc de Triomphe* in Paris'. Architectural taste changed and when the grand arch was demolished in 1963 to create more space, together with the station's great hall and magnificent hotel of 1881 by Philip Hardwick, there was huge protest from preservationists. The new station, opened in 1968, simply lacked the architectural presence of its Victorian predecessor. The two earlier 'hotels' at the station's front, though, survived. When opened in 1839, these attractive buildings provided accommodation: 'Victoria', served breakfast only and the second, 'Euston' offered a full menu. Euston is due for another huge upheaval when the new, high-speed line to Birmingham is built.

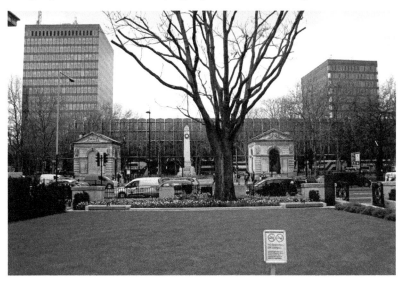

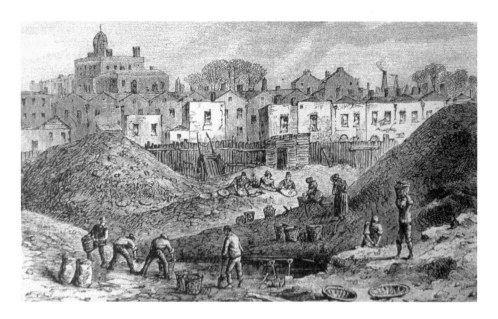

The Dustheaps, Somers Town

Astonishingly, these mountainous dustheaps were a well-known feature of Victorian London, at Somers Town, where London's accumulated rubbish was tipped, just north of the Euston Road. There was money in rubbish as Charles Dickens satirised through the character of Mr Boffin, 'The Golden Dustman' in *Our Mutual Friend*. *Old and New London* mentions that the area descended from being the former grounds of a mansion to an 'abomination of desolation', at its centre, 'a dreary and unsavoury locality' where 'wretched creatures in rags and dirt searched for treasure...' The British Library, 'the largest public building constructed in the United Kingdom in the 20th century' was opened here in 1998. The library, designed by Colin St John Wilson, was created by an Act of 1972 to replace the library of the British Museum, which had become too small for the purpose. The shelves contain millions of books and manuscripts, from Magna Carta to the Beatles. The library is overlooked by St Pancras Station and Hotel to the east, rising above like a fairy tale castle.

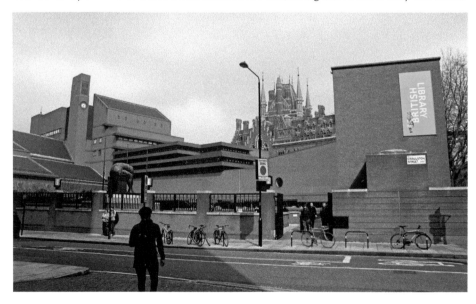

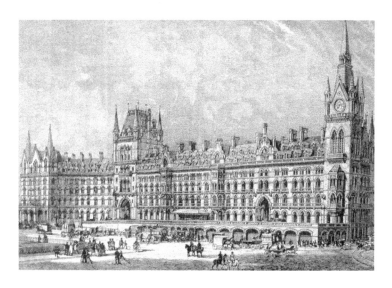

Front of St Pancras Station and Hotel

Built as the Midland Railway's terminus, this magnificent Victorian Gothic station is one of the capital's great sights. The '...astonishing towered and pinnacled skyline still catches the eye and thrills the imagination of the explorer of London'. (Bradley, 2007.) Nevertheless, many streets and thousands of houses had to be demolished for the scheme. Facing the Euston Road, the Midland Grand Hotel, designed by George Gilbert Scott, was completed in 1872 and incorporated a 270-foot-high clock tower with a mechanism by John Walker, a London clockmaker of Cornhill. Fashions change and 'the best conducted hotel in the Empire' closed in 1935 and became offices. There were even threats of demolition in 1970s but the hotel survived and was renovated and rebranded to become today's St Pancras Renaissance Hotel, claiming to have 'the longest champagne bar in Europe'. The enormous train shed, by W. H. Barlow and R. M. Ordish, sits behind the hotel frontage and spans 240 feet, the largest single span in the world when finished. The station has been extensively converted to run the London to Paris Eurostar train service. This conversion made practical use of the capacious old beer store underneath the station, originally used by Burton Brewers. (Bradley.)

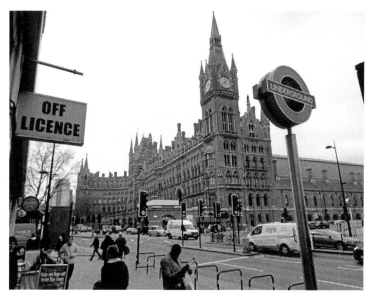

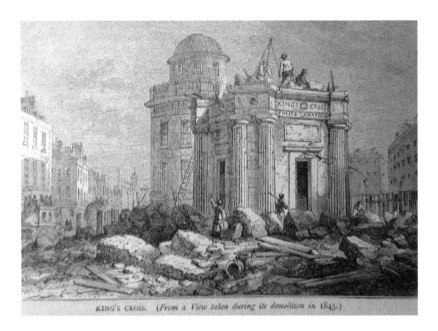

KING'S CROSS. (*From a View taken during its demolition in 1845.*)

King's Cross (from a View Taken During its Demolition in 1845)

In contrast to nearby St Pancras's architectural exuberance, the sober front of the Great Northern Railway's terminus at King's Cross seems to make a virtue of functionality. The twin train sheds by Lewis Cubitt, were completed in 1852 with a plain façade of London stock brick. The Victorian concept included a six-storey granary and stabling for 600 horses under the good platform. Lewis Cubbit added the Great Northern Hotel in 1854, 'the world's first great railway hotel', recently rebranded as a boutique hotel, the 'Tribute Portfolio Hotel'. *Old and New London* mentions that the area was called 'Battle Bridge' before it was renamed 'King's Cross' after the 'ridiculous octagonal structure, crowned by an absurd statue' of King George IV that stood here. There was a fallacious Victorian antiquarian opinion that Queen Boadicea was defeated by the Roman army here and even that she was buried under what later became platform 10 of King's Cross station. (Roud, 2008).

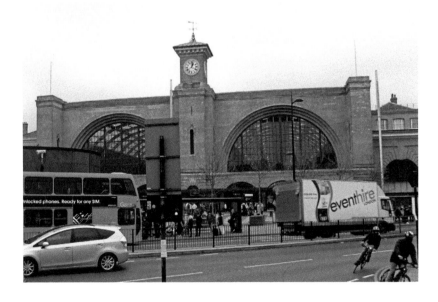

View in Highgate Cemetery

If railways stations were a great invention, transporting people in this life, then another Victorian innovation, cemeteries, was significant too, for accepting people's remains at the terminus of the final journey from birth to death. The overcrowded churchyards of London's traditional parishes, often layers deep in bodies, simply could not cope any more with the city's increasing numbers. Highgate Cemetery, north London, was established by the Highgate Cemetery Company, founded by Stephen Geary, architect and civil engineer, who also planned the layout. The cemetery was consecrated by the bishop of London in 1839 and proved a marked success. In the 1960s the cemetery became neglected but thrives again, 'saved by its friends' under new management. The Communist hero Karl Marx is famously buried here but the grave of another hero also deserves mention, 'the well-known pugilist' Tom Sayers (1826–65). He fought the much bigger American Jack Heenan for the champion belt of the world. Tom lost but hit the headlines and was awarded a purse of £1,000 by the Stock Exchange. A sculpture of his bull mastiff, 'Lion' guards Tom's tomb. (Highgate Cemetery Guide.)

CHAPTER 3

The Southern Suburbs

Old and New London included many sights of South London but, putting this in the style of the Victorian author, only the more typical or the most exceptional need detain us.

SUB-TROPICAL CARDEN

IN BATTERSEA PARK

ST THOMAS'S HOSPITAL

LONDON.

THE SOUTHERN SUBURBS.

CHAPTER I.

INTRODUCTORY.—SOUTHWARK.

" Superat pars altera curæ."—*Virgil.*

Introductory Remarks—Geological Observations—Earliest Mention of Southwark in History—Its Etymology—Southwark as a Roman Settlement—Old London Bridge—Knut's Trench—Reception of William the Conqueror by the Natives of Southwark—The Civic Government of Southwark—Its Annexation to the City—An Icelander's Account of Old London Bridge—The Story of Olaf's Destruction of the Bridge—Hymn sung on the Festival of St. Olave.

HAVING now completed our survey of the West End and of the northern suburbs of London, it will be necessary for us again to take in hand our pilgrim staff, and to make a fresh start, with a view of reconnoitring that large and interesting district which, though it lies on the southern bank of the Thames, forms, and has formed for centuries, an integral part of this great metropolis. We will therefore do so without further delay, and only ask our readers to accompany us mentally to

ST SAVIOUR'S SOUTHWARK

LAMBETH PALACE

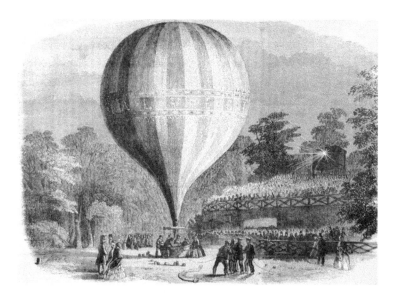

Balloon Ascent at Vauxhall Gardens

The site of London's once popular attraction Vauxhall Gardens is marked today by a small public park and a city farm owned by the Borough of Lambeth. The gardens were a special place of entertainment, spectacle and assignation in the eighteenth century. The gardens were finally closed in 1859 after fashions changed and they had become rather dowdy and unfrequented. The land was redeveloped with housing which suffered badly from Second World War bombing and was cleared in the 1970s for the present local community park. Briefly, though, the gardens enjoyed a resurgence in the nineteenth century as a venue for balloon flights, especially when the noted aeronaut, Charles Green, took passengers up in the basket. A good impression of Vauxhall Gardens in their heyday can be gained by visiting the exhibition gallery at the Museum of London. (Vauxhall Gardens Online). Today, the small area is overlooked by the bulk of the MI6 Headquarters building, designed by Terry Farrell and made famous in recent Bond films, which stands on the south bank of the Thames. A west entrance was created for the present park next to a Victorian pub, the Royal Vauxhall Tavern, which has become a noted gay venue and a 'training-stage' for comedians and cabaret artists.

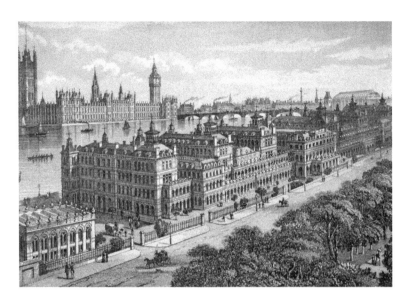

St Thomas's Hospital

St Thomas's has a long history. It can be traced back to the sick house of the church of St Mary Ouverie, named in 1173 after the murdered Archbishop Thomas Becket, which stood in the yard of Southwark Cathedral. A new building was occupied in 1709 and St Thomas's became medically respected. When land was cleared for London Bridge station in 1862, St Thomas's was forced to move out. Eventually, a new site was acquired at the south west end of Westminster Bridge. The present hospital, built to the designs of Henry Currey, was opened in 1872. Florence Nightingale, of Crimean War fame, greatly influenced the design and the focus on space, light, hygiene and health. In 1900, a statue of Florence Nightingale was added to the Guards Crimean War Memorial in Waterloo Place, off Pall Mall, opposite the Reform Club. A new east wing was completed in 1966. Between this wing and the Thames stands a recent statue of Mary Seacole, a Jamaican-born nurse, who also cared for wounded troops in the Crimean War. This memorial statue is believed to be the first in honour of a named black woman. (BBC London News 30.06.2016). St Thomas's staff rushed to help people injured on Westminster Bridge in the terrorist outrage of 22 March 2017.

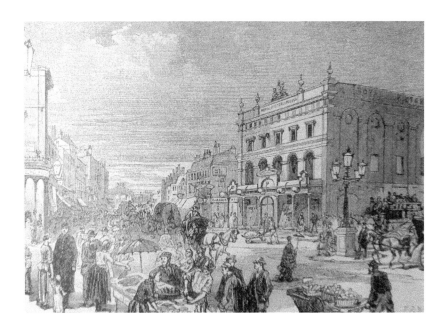

View in The New Cut

The New Cut (now The Cut) and Lower Marsh street markets were notorious in Victorian London as the haunt of sneak thieves and prostitutes. Henry Mayhew counted over three hundred stalls selling almost everything: straw bonnets, fruit and vegetables and hot eels. Measures were taken to control the market which had the lively character of a fair. There is still a market in Lower Marsh today but it is much quieter. The Royal Coburg Theatre was opened on the corner in 1818. It was renamed The Royal Victoria Theatre, hence the name that has survived through alterations and modernisation, 'the Old Vic'. For a time, the theatre was a temperance music-hall for the working classes. Famous music-hall artistes of the time would be seen calling on their agents locally 'between engagements'. Lilian Bayliss took over the management early in the 20th century and the venue became famous for popularising the plays of William Shakespeare. The Old Vic was briefly the National theatre under Sir Laurence Olivier. (*London Encyclopaedia*, 1983)

The Chartist Meeting on Kennington Common, 1848 (from a Contemporary Print)

The Chartists were a mid-nineteenth-century radical political organisation that agitated for political reform, set out in their charter. A key demand was for the basic right to vote for 'members of Parliament by every male of twenty-one years of age and of sound mind'. They assembled on Kennington Common to petition the government to accept the points of the charter on 10 April 1848. The numbers attending were officially disputed but probably exaggerated by the Chartists. There were, perhaps, 15,000 assembled on the common, including some women despite their inevitable omission from the charter in that era. Many Chartists had taken advantage of the new railways to travel in from provincial towns. The government feared a violent attack on Parliament, mindful not only of that year's February revolution in Paris but also having a long memory of the Gordon Riots that swept London in 1780. Defensive measures, therefore, were taken. The Bank of England was fortified and troops were on standby under the command of the Duke of Wellington. Over 100,000 special constables were sworn in. There was no plan for revolution in London and the Chartists dispersed quietly (Cole and Filson, 1967). The disreputable old common is now Lambeth's Kennington Park. The present view was taken from the right of where the crowd stood, looking across the meeting, north-eastwards, with the Shard visible in the far distance.

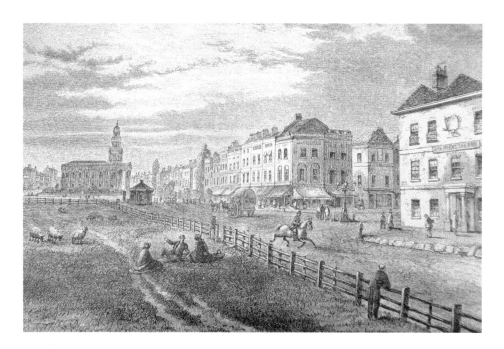

Kennington Commons and Church in 1830

The old views shows not only Kennington Common but also, fascinatingly, 'The Horns Tavern'. The old name perhaps refers to the tradition and very practical custom of incoming coaches 'sounding the horn', announcing their forthcoming arrival at the next inn on the route for refreshment and a change of horses. The previous engraving of the Chartist meeting in 1848 was, unusually for *Old and New London*, taken from a daguerreotype supposedly taken from 'The Horns'. The British Library has one of these photographs, said to be the first crowd photograph ever taken. 'The Horns' was demolished and the site is now occupied by a local Health and Social Security Office.

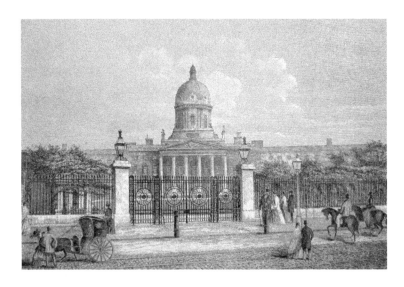

Front View of Bethlehem Hospital

This mental institution had distant medieval antecedents in a hospital attached to the Priory of St Mary Bethlehem outside Bishopsgate, just north of the City walls. After many changes, this was re-established in 1676 at Moorfields, east of the City, in an architecturally pleasing new building by Robert Hooke. Mental illness was not understood and there are cruel accounts that the inmates or 'lunatics' were kept like caged animals and the curious public were even admitted to view these unfortunates. The care and understanding of mental affliction improved in the nineteenth century and patients were admitted to secure asylums for treatment. A new building was constructed at Lambeth and patients were transferred there from Moorfields. The dome and portico were added by Sydney Smirke in 1834. The first resident medical officer, Dr W. Charles Hood, appointed in 1851, introduced an enlightened regime without the old restraints on patients. In the early twentieth century, the patients were transferred to other premises outside London. The Imperial War Museum, founded in 1917, moved into the vacated premises in 1936. The great naval guns clearly announce the building's present function.

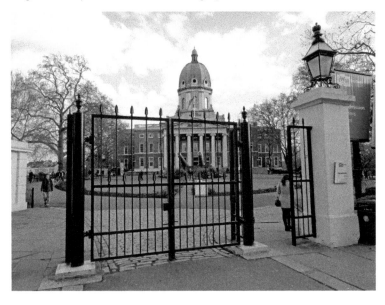

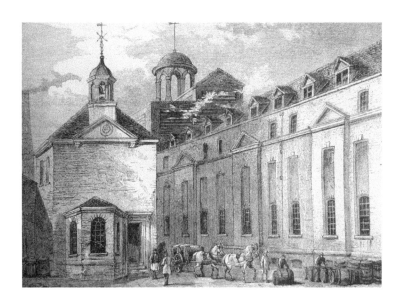

Barclay's Brewery, 1829

Henry Thrale inherited an old brewery at Bankside in 1758. He was ambitious to become 'the greatest brewer in London'. He and Mrs Thrale often entertained the great Dr Johnson. Thrale expanded the business and purchased the site where Shakespeare's Globe Theatre stood (occupied today by the replica) and the site where the present Anchor Tavern stands. On Thrale's death in 1781, the brewery was purchased by Robert Barclay, who went into partnership with John Perkins and founded Barclay and Perkins, also known as the Anchor Brewery. This brewery operated on a famously huge scale and exported worldwide, including the Russian court, hence 'Imperial Russian Stout'. The brewery exemplified Victorian industrialisation and brewed over half a million gallons of beer in 1875. The buildings were demolished in 1981 but are marked by a plaque fixed to the wall of the low-rise housing of Park Street, overlooked by the Shard. Another plaque marks the spot where incensed brewery workers attacked a visiting VIP in 1850, the so-called 'Austrian Butcher' General Julius Jacob von Haynau, infamous for brutally repressing the 1848 revolutions in Italy and Hungary. (Exploring Southwark Online)

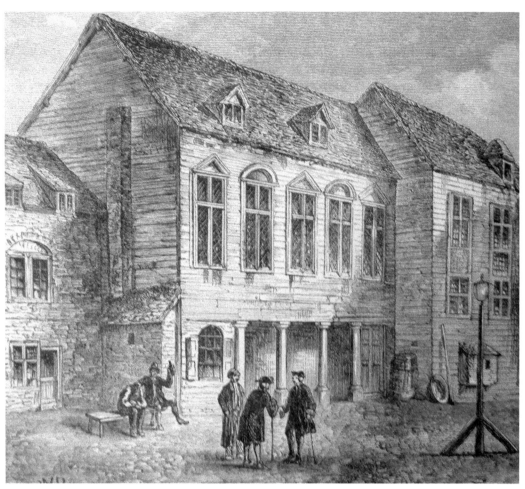

The Marshalsea Prison in the Eighteenth Century

Although of much older foundation, 'The Marshalsea', closed in 1842, retained a frightening aura even in the Victorian era. Off Borough High Street, in a small park, a surviving wall runs along an alleyway now called Angel Place. In the background, the Shard soars above. This was once part of the prison. Charles Dickens's father was imprisoned here for debt in 1824. The author used the prison as theme for his novel *Little Dorrit*. William Dorrit was incarcerated for debt for many years (as was the punishment at the time), and his daughter, Little Dorrit, was even born there and christened at St George's Church nearby. The Borough of Southwark has immortalised Dickens's unfortunate heroine by creating 'Little Dorrit Playground', as the sign shows. (Jane Austen's World Online blog)

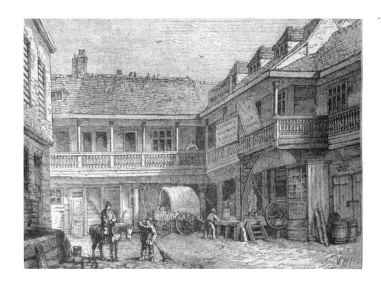

The Old 'Tabard' Inn from a Sketch Taken Shortly Before Its Demolition

London attracts many communities and is a global stage for political demonstrations. These demonstrators are in Borough High Street, outside the historic George Inn. Although partly demolished by the railway in the late nineteenth century, much of the structure stands. Familiar to Charles Dickens, it is the only galleried coaching inn left in London. Perhaps uniquely, the inn is owned by the National Trust. Further down the block, the Tabard Inn was not so lucky. This was where the pilgrims of Geoffrey Chaucer's *Canterbury Tales* assembled. After Chaucer's time, the inn fell into disrepair, was restored but was burned down in 1676. The inn was rebuilt, posing an obvious historical question: how much of it was original at that point. With the demise of coaching in the 1830s, the Tabard was acquired by a railway company and demolished in 1873. At one point in its life, the Tabard was ignorantly known as the Talbot and it stood in the present Talbot Yard. Today, only an old Guy's Hospital building is visible.

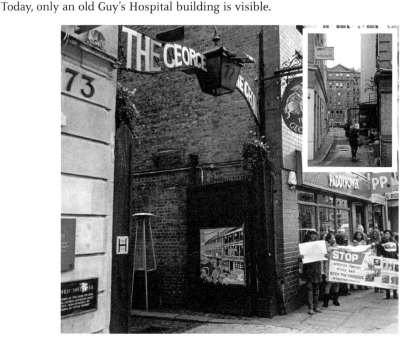

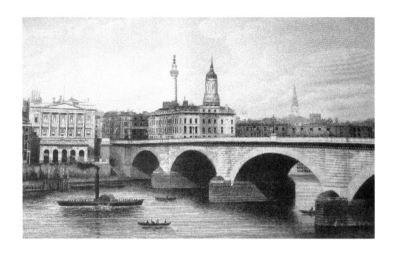

London Bridge

London Bridge, originally built of wood during the Roman occupation, was not only the first bridge spanning the Thames at London, it was for long the only such crossing, apart from ferries. Because of the traditional rhyme, *London Bridge is Falling Down*, it is the most famous bridge in the English-speaking world. The rhyme has been subjected to much analysis – even that it alludes to human sacrifice. This idea seems rather speculative given that the earliest known version of the words was published in 1744. (Roud 2008.) A replacement stone bridge of nineteen small arches with a drawbridge at the Southwark end was completed in 1176. Currents were fierce and vessels 'shooting' the bridge risked disaster. Houses were even built upon it, although these were removed as an encumbrance in the eighteenth century and a wider central arch for better navigation was created. It became the custom to exhibit the heads of traitors on the bridge: Wat Tyler, leader of the Peasants' Revolt in 1381 and Jack Cade whose rebels attacked London in 1450 are examples. A new bridge of five stone arches, designed by Sir John Rennie, was opened in 1831, a little upstream or west of the old one. This was replaced in 1972 by the present three-span, pre-stressed concrete bridge built by Mott, Hay and Anderson with Lord Holford as adviser. The stonework of the old bridge was sold and re-erected at Lake Havasu City, Arizona, USA. (*The London Encyclopaedia*, 1983.) Some of the old stonework survived however, including the steps that descend at the south-west end of the present bridge. These were known as 'Nancy's Steps' after the tragic character brutally murdered by Bill Sikes in Charles's Dickens's *Oliver Twist*.

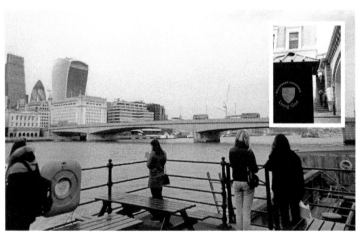

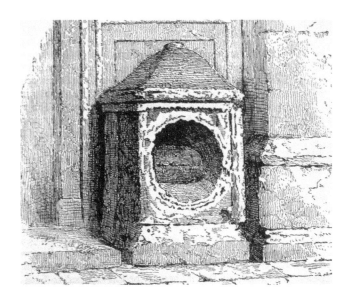

London Stone

London Bridge is the direct route from Southwark, south of the river, back into the City. Until recently, the so-called 'London Stone' could be seen, embedded in a wall behind a grill, on one of the buildings formerly standing immediately north of Cannon Street station in the City. The mysterious stone has been safely removed to the Museum of London and is on display until rebuilding is complete, when it will be replaced *in situ*. As Roud describes, the stone has been the subject of an immense amount of folkloric and antiquarian speculation; for example, it was the point from which the Romans measured all distances in England or, it marked the exact centre of the medieval City. In William Shakespeare's *Henry VI*, Part 2, the rebel, Jack Cade, strikes the stone with his sword and this act validated his claim to be lord of the city. There are some wilder modern theories: that the stone was brought by Brutus when he founded the City or that it is the last surviving fragment of a series of sacred monoliths. Roud reviews the theories and evidence relating to the London Stone and concludes that the stone has simply been a landmark since the eleventh century and has no symbolic ritual power or deep meaning. (Roud 2008).

Epilogue: The Embankment

Of all London's Victorian improvements, Sir Joseph Bazalgette's Victoria Embankment is perhaps the most impressive. Architecturally distinguished and elegant and also supremely functional, embanking the Thames, forming a major new highway between the City and Westminster, housing the underground railway and services and also containing the great, low-level intercepting sewer. If the Georgians could have travelled in time and enjoyed a perambulation to Westminster, they would no doubt have been completely astonished at the sight.

The Embankment is not only a magnificent structure but also features a wealth of Victorian decorative detail in the thematic designs of the lamp columns and the seats – an altogether marvellous public space, especially in the early spring sunshine. One design features the letters 'MBW', the newly created Victorian London authority the Metropolitan Board of Works that enabled this great project to be undertaken. Unsurprisingly, the Embankment attracts today's artists, just as the great Impressionist painter Claude Monet was attracted to the scene in the Victorian era.

An heraldic griffin marks the City boundary and the tall silhouette of 'Big Ben' or, more correctly, the Queen Elizabeth Tower with its distinctive clock face and Great Bell, chiming the hours and quarters, announces arrival at Westminster. There, the statue of Boadicea, legendary warrior queen of the ancient British tribe, the Iceni was set up in 1902, the year following Queen Victoria's death. Like the adjoining Palace of Westminster, the design reflected Victorian national aspirations. Victoria's Consort, Prince Albert, influenced the selection of the designs both for the Palace and for the statue which, in a sense, symbolized the power of Queen Victoria herself, 'Empress of India'.

Above left: 'Georgians' time-travelling, as it were, enjoying a perambulation westwards along the Victoria Embankment, which would have been an area of extensive muddy banks in their century.

Above right: A 'sturgeon' lamp column on the Embankment with Waterloo Bridge in the background.

The initials 'MBW' stand for Metropolitan Board of Works, the new Victorian authority responsible for the Embankment and other London improvements.

Neptune's face is cast into the bases of many of the columns.

Left: The Victoria Embankment has long been a popular haunt of artists, looking west to Westminster in this case.

Below: Queen Boadicea Statue, Westminster, sculpted 1856–83 by Thomas Thornycroft but not set up until 1902.

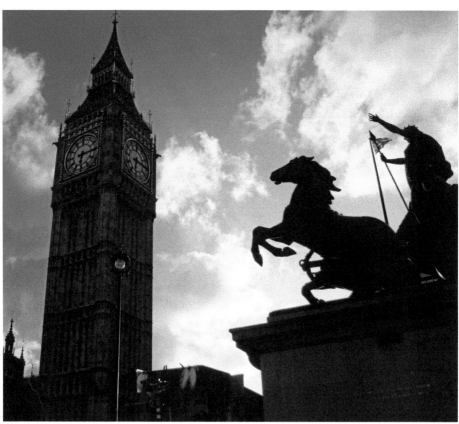

About the Author

Colin Manton studied science at school and, on leaving, worked in an actuarial department. These experiences gave him an interest in technology and in City finance. He took his degree in history at Southampton University. After graduation, he trained as a museum curator and worked in the profession for over twenty years. His next move was into university lecturing and also adult education tutoring. The courses that he currently presents include 'Victorian London' and 'English Folklore'. His previous publications include *Bygone Billingsgate* (Phillimore, 1989) and *Haywards Heath Through Time* (Amberley, 2013).

Acknowledgements

The author wishes to thank students, past and present, of his 'Victorian London' courses taught at the Centre for Continuing Education, University of Sussex, and also under the aegis of the Workers Educational Association (Southern Region). He also wishes to thank his editor, Becky Cousins, and also to acknowledge the work of the editors and contributors of *The Encyclopaedia of London*, an absorbing and indispensible work of reference.

Bibliography

Adburgham, A., *Shops and Shopping 1800–1914* (1989).

Bradley, S., *St Pancras Station* (2007).

Cole, G. D. H. and Filson, A. W., *British Working Class Documents: select documents 1789–1875* (1967).

Davis, J. R, *The Great Exhibition* (1999).

Dickens, C., *Sketches by Boz: Illustrative of Every-day Life and Every-day People* (1839; later biographical edition of the works of Charles Dickens in nineteen volumes, Vol. I undated).

Dickens, M. (foreword), *The London of Charles Dickens* (1970).

Dodd, G., *Days at the Factories: or, the Manufacturing Industry of Great Britain Described* (1843; modern facsimile edition, undated – possibly 2014).

Doré, G. and Jerrold, B., *London: a Pilgrimage* (1872; Dover facsimile edition 1970).

Mayhew, H., *London Labour and the London Poor* (1861–62; Dover facsimile edition, 4 vols, 1968).

Friends of Highgate Cemetery *Highgate Cemetery, saved by its Friends* (undated, possibly 2016).

Halliday, S., *The Great Stink of London: Sir Joseph Bazalgette and the Cleansing of the Victorian Metropolis* (2001).

Halliday, S., *Making the Metropolis: Creators of Victoria's London* (2003).

Hall, P. G., *The Industries of London Since 1861* (1962).

Jackson, L., *Walking Dickens' London* (2012).

Manton, C. and Edwards, J., *Bygone Billingsgate* (1989).

Olsen, D. J. Olsen, *The Growth of Victorian London* (1979).

Picard, L., *Victorian London: The Life of a City 1840–1870* (2005).

Porter, R., *London: a Social History* (1994).

Rasmussen, S. E., *London: the unique city* (1960).

Roud, S., *London Lore: the Legends and Traditions of the World's Most Vibrant City* (2008).

Thornbury, G. W. and Walford, E. *Old and New London: a narrative of its history, its people, and its places*, Vols I–VI (1872 onwards).

Weinreb, B. and Hibbert, C. (eds), *The London Encyclopaedia* (1983).

Websites

'Sadiq Khan - Full mayoral acceptance speech', BBC London News 06.05.16, at https://www.youtube.com/watch?v=uuz1ofZgZ_o (30.04.17).

'London attack: Police officer Keith Palmer among four dead as terror strikes in the heart of Westminster' Mark Chandler, Francesca Gillett, *Evening Standard,* Wednesday 22 March 2017, http://www.standard.co.uk/news/crime/london-attack-police-officer-among-four-dead-as-terror-strikes-in-the-heart-of-westminster-a3496861.html.

BHO British History Online 'Survey of London', http://www.british-history.ac.uk/search/series/survey-london.

Greenwood's Map of London 1827, http://users.bathspa.ac.uk/greenwood/imagemap.html.

Cross's London Guide 1844, http://mapco.net/cross1844/cross10.htm.

Map of London 1868 by Edward Weller, http://london1868.com.

Jane Austen blog, https://janeaustensworld.wordpress.com/2009/04/06/little-dorrit-the-father-of-the-marshalsea-the-prison-within-the-prisoner/.

'Mary Seacole Statue Unveiled in London', BBC London News 30.06.17, http://www.bbc.co.uk/news/uk-england-london-36663206.

'Failed Chartist Demonstration' *History Today* 04.04.17, http://www.historytoday.com/richard-cavendish/failed-chartist-demonstration-london.

'Kennington Common Photograph' British Library, http://www.bl.uk/learning/histcitizen/21cc/struggle/chartists1/historicalsources/source6/kenningtoncommon.html.

'Barclay Perkins and Co- Anchor Brewery' Exploring Southwark Online http://www.exploringsouthwark.co.uk.

Vauxhall Gardens Online, www.vauxhallgardens.com/vauxhall_gardens_briefhistory_page.html.